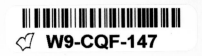

Cars in color

cars in color

Introduction and notes by Michael Sedgwick

A STUDIO BOOK THE VIKING PRESS NEW YORK

Published in 1968 by The Viking Press, Inc.
625 Madison Avenue, New York, N.Y. 10022

Library of Congress catalog card number: 68-29052

Printed and bound in Denmark by F. E. Bording Ltd, Copenhagen

Contents

Acknowledgement

The Publishers wish to thank the following for permission to reproduce photographs appearing in this book:

The Antique Automobile Club of America for page 49; *Automobile Quarterly Magazine*, New York, for page 109; Mr Ronald Barker for pages 81 and 163; Mr James Barron for pages 29, 37, 39, 43, 55, 57, 59, 61, 63, 65, 67, 69, 71, 75, 91 and 107; Mr Michael Buckley for page 93; Mr Edward Eves for pages 147 and 151; Mr Louis Klementaski for pages 125, 129, 133, 135 and 137; Mr Henry N. Manney III for pages 131, 137, 143, 145, 153, 155, 157, 159, 161, 165 and 169; Mr T. C. March for page 121; Mr G. C. Monkhouse for pages 117 and 119; the Montagu Motor Museum for pages 27, 31, 33, 35, 41, 45, 47, 51 and 53; *Motor Sport* for page 173; and Mr H. B. Willis for page 77.

Introduction

The motor-car has become not only an integral part of our lives: it has become a cult. To prove the former assertion one has only to infiltrate any commuters' artery, from Sydney Harbour Bridge to the Los Angeles Freeway, between 5.30 and 6 p.m.: evidence of the latter is found in the crowds that turn the Brighton Run into a penance, and throng the aisles of motor museums. Even away from the esoteric world of the antique, the public is more car-conscious than ever before. A generation ago, if father had a Citröen, Buick or Austin, the same breed was good enough for his son. Now the automobile is venerated, discussed everywhere in quasi-technical jargon, and we all imagine that we know why 1959 was a very good year of the $1\frac{1}{2}$-litre so-and-so. The sports car, once a symptom of prolonged adolescence or a superior bank balance, has been transformed into a sex-symbol. Motor racing has become at the same time more and less rarefied. True, the young man of means can no longer enter the sport by buying £1,000-worth of Type 35 Bugatti, 'the same as the big boys drive', but the old Brooklands slogan, 'the right crowd and no crowding', is as dead as Jacob Marley. There is nothing 'snob' to spectating at Silverstone or Monza, any more than there is about an afternoon at Stamford Bridge or the local baseball stadium.

It might be said that the motor-car has come full circle, from the menace of the new-fangled Juggernaut, that caused maiden ladies to palpitate, and cart-horses to acquire an Aintree-complex, to the menace of the over-familiar: the mass-killer, the status-symbol, the blocker-up of vital arteries, and the dispenser of noxious fumes, tolerated only

because it gives employment to so many (according to recent statistics, 12 million Americans alone), and because it is a 'natural' for the tax-gatherers. It is certainly true that the rise of a new anti-motoring clique has spurred the romanticists. Having read their history, from Benz to Wankel, they take refuge in special periods and special pleading. They may revel in the Age of Experimentation, when a combination of total-loss cooling and lubrication, unsealed roads, a constabulary riddled with ignorance and prejudice, and no technical guru to help the unwary motorist penetrate his maze of belts and greasers, rendered the New Locomotion a hazardous adventure. They may seek refuge in the golden 'Edwardian' years (which reached their peak after Edward VII's death)—by which time the motor-car had been made to work admirably, and had better (and still empty) roads upon which to perform.

Perhaps memories of tyres that seldom lasted more than 3,000 miles, the caprices of acetylene lighting, two-wheel brakes, and clutches that required frequent dressing, not to mention the tedius processes needed to keep paint and varnish pristine, may dog them; then they will opt for the Vintage period, in which such conditions gave way to cellulose, chromium plate, fool-proof braking systems, and engines that started at the press of a button. Still an era, be it said, in which a Bentley, a Hispano-Suiza, a Bugatti or a Mercedes possessed an identity of its own, to worship or to execrate (say what one may, it is hard to bow down before a Mini or a Volkswagen, however much one may admire the qualities that have made them best-sellers).

The present writer, being Vintage by birth, tends to preserve a tender spot for the cars of the 1930s—partly because he served his apprenticeship on those rather than on Austin Sevens and Bullnose 'Cowleys', and partly because the best that this period could offer combined the genuine (as opposed to suppositious) 'Vintage' virtues, and the refinements of a later era—synchromesh gearboxes, hydraulic brakes, good

handling, and a quality and elegance of bodywork which more than off-sets the more tiresome shibboleths of Classicism—the slit windscreen obscured by twin overslung wipers, the low and claustrophobic driving position, and the yards and yards of bonnet. The motor-car, after all, reached its zenith as well as its nadir in this period. Real radiators and exposed headlamps might represent drag, but the curses of streamlining manifest themselves when one penetrates under the bonnets of moderns. We may be learning more about steering geometry, and be designing entities instead of chassis and bodies, but how many of us hanker for proper instruments instead of warning lights which make us dive for the handbook on an unfamiliar vehicle; for opening windscreens; for starting-handles; and for doors which don't have to be slammed?

This is no pictorial history of the motor-car. It would be impossible to summarise in 80 examples the evolution of design from 1888 to 1961, if only because readers would insist that these were the wrong 80. What of the Curved Dash Oldsmobile, the world's first mass-production automobile? Why no 'Silver Ghost'? Why include the Cord, which found less than 3,000 customers in two seasons, and yet pass over the 750,000 *traction avant* Citröens, the delight of Frenchmen from François Lecot to Inspector Maigret? Many Americans who were in their 'teens in the days of the Mercer–Stutz rivalry probably never saw either, and will lament the absence of the Maxwells and Overlands that chugged down Main Street.

But it is possible to look at the motor-car sociologically without such painful and controversial selection. In 1900, to see one was a treat, and to ride in one a treat won (by the distaff side) at the price of self-camou-flage behind a wall of unsightly and ursine attire. A Rolls or an Edge might choose to motor seriously for business, but otherwise the appeal was to the adventurous, and no average parent would have countered the motorphobia of Belloc's Hildebrand with a nonchalant 'We'll off

to town and purchase some'. Had he done so, he would have employed 'motor servants' for the menial tasks of maintenance, while writing letters to the motoring press to prove that his de Dion cost less per mile than the horse it had supplanted. Gradually the situation changed, and by 1910 the motor-car had penetrated the middle classes, though it was still far from cheap, demanded liberal greasing and varnishing, had a healthy thirst for rubber, and was not backed by 'nation-wide factory service' (£250 might buy a 10 h.p. two-seater, which a lady with strong wrists could start and operate, but spares came from London, if not from Paris).

Then came the impact of the Ford, and with it mass-production. Thence the trend was towards a vehicle that was cheap to buy, easy to service, and so simple to operate that a layman could conduct it seven days a week without constant recourse either to the prolixities of the instruction manual, or to hired professional assistance. Some of the ploys of the designer in this period would seem odd today—the Americans eschewed the detachable wheel until 1931 on the grounds that ladies would find it easier to change only the rim!

It is not true to say that the sports car was born of mass-production. It stemmed from the desire to go faster and to drive for pure fun, and was inevitable once reliability had been attained; thus the market was opened up by Benz, de Dion-Bouton and Renault as much as by Ford. But the Ford influence meant standardisation, and as the family car became a part of our lives, so the individualist sought something 'out of the rut'. And these specialist vehicles, though in numbers insignificant, are the ones that have lived in our memories.

Hence the reader will find few later specimens of the commonplace in this book. The post-1945 period, in fact, is covered solely by the esoteric—sports cars either beyond the average motorist's pocket, or lacking the accommodation demanded by family holidays on the Costa

Brava, and racing cars which he will have encountered only from behind the crash-barriers or upon the television screen. The sports car, as we have seen, is not too far divorced from our world for inclusion, but why racers? Not, surely, because the racing car of today is the touring car of tomorrow? It is true that after Jenatzy's victory in the 1903 Gordon Bennett Cup on a 60 h.p. Mercédès, the makers were inundated with orders for similar cars, and these were to be seen, not only as *tonneaux,* but as closed barouches. Even the *monoposto* Alfa of the 1930s has been converted on occasion for road use. But what is the significance of a rear-engined Lotus, or a behemoth designed specifically to circle the bricks of Indianapolis for 500 miles? Yet consider: modern cars have hydraulically actuated disc brakes, proven on the circuit by Jaguar; Connaught, Maserati and Mercedes-Benz experimented with fuel injection. One could go on for ever. Consider also the ingenuity with which changes of Formula rules have been circumvented. These range from the comedy of the unlimited piston strokes found in early *voiturette* racing, which ended in engines so high that drivers had to look round, rather than over them, to the emergence of the low-profile, rear-engined machinery to today as the consequence of the standardisation of Avgas and the 300-kilometre Grand Prix in 1958.

But whatever your viewpoint, most of the cars we have selected have personality. The writer of these lines may groan every time he gropes for an illogically-located switch on a strange machine—but only momentarily. *Vive la différence.*

Here stands the genesis of dependable motor transport. Karl Benz's conservatism has been the Aunt Sally for generations of historians, and all too often he has been judged on his adherence to his original concept as late as 1902. But he had a car in small-series production in 1888, even if this primitive device with rear-mounted single-cylinder horizontal engine, exposed vertical crankshaft, and horizontal flywheel was hard put to it to achieve 12 m.p.h. on the level. Horse-carriage influence is apparent in the solid tyres, block-type brakes, victoria coachwork and fragile steering pivot. The 'total-loss' cooling system meant frequent halts to take on water, but Benz, unlike Daimler, used electric ignition.

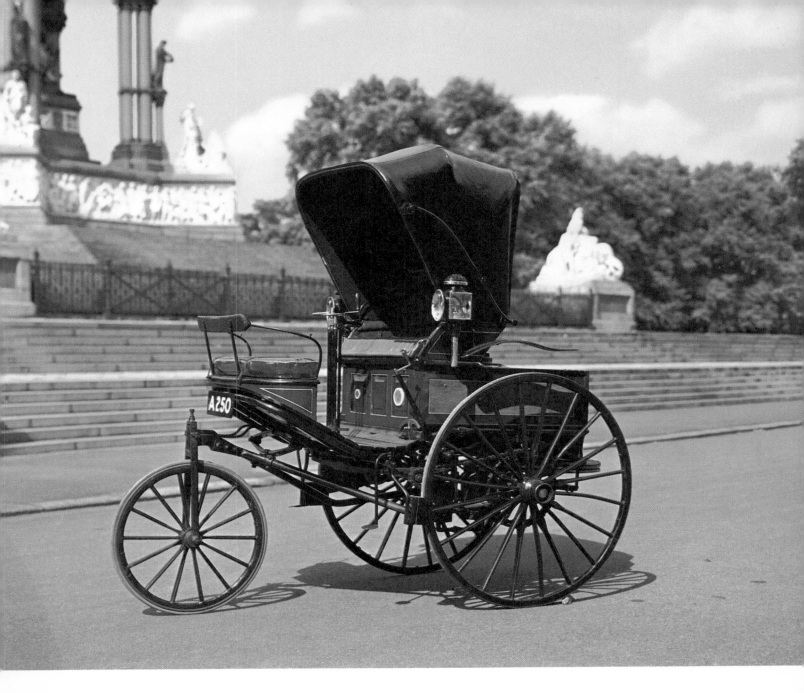

ROGER-BENZ 1½ h.p., 1888

With few exceptions Britain's first cars were based on French and German designs, and initially 'Coventry' Daimlers were in fact made at Cannstatt. Here is one of the first genuine Coventry models with Mulliner bodywork. Apart from the $1\frac{1}{2}$-litre Phoenix-Daimler twin-cylinder engine, developing 6 b.h.p. at 950 r.p.m., the design is Panhard, with the power unit in front, a gearbox amidships, and chain drive to the rear wheels. The gearbox has four speeds, but hippomobile influence is still evident in the unequal-sized wheels and body styling, while the car is tiller-steered. On this example electric ignition has replaced the hot-tube system originally fitted.

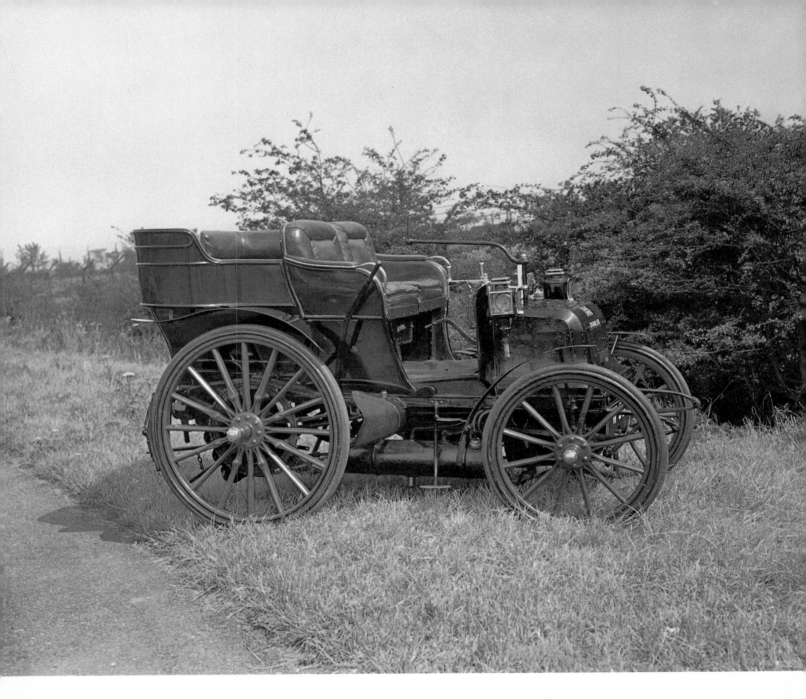

COVENTRY-DAIMLER 4½ h.p., 1897

In 1899 D. Napier & Son, makers of minting machinery, entered the automobile industry by converting a Panhard to take their own engine. Their first production car was this 8 h.p., marketed by S. F. Edge's Motor Power Co. It owed a great deal to Panhard influence, retaining that firm's reverse gear, by which the drive was transferred from one bevel gear on the countershaft to another, allowing a choice of four ratios in either direction. Perilous, perhaps, but the legal speed limit in Britain was still 12 m.p.h., and with low gearing and solid tyres 18 m.p.h. is about the maximum for this machine. Pneumatic tyres were fitted to Edge's personal car in 1900, and standardised a year later. Ignition is by trembler coil, and the radiator is at the rear.

NAPIER 8 h.p., 1900

The conservative style of this little vehicle—produced in 'the year of the Mercédès'—should not blind one to its advanced design. As early as 1895 the Comte De Dion and Georges Bouton had made a $\frac{3}{4}$-h.p. single-cylinder engine capable of rotating at 1,800 r.p.m., or twice as fast as the contemporary 'high-speed' Daimler. From motor-tricycles the firm had progressed, by 1899, to a light car, and this Type-G is powered by a 500-c.c. water-cooled unit under the driver's seat, direct-coupled to a two-speed constant-mesh gear: each speed is brought into action by its own expanding clutch. Selection is *via* a steering-column lever, and final drive by a De Dion axle with independent, universally-jointed halfshafts. Here is the true ancestor of the modern light car—inexpensive, easy to maintain, and simple to conduct (except to those inured to synchromesh).

DE DION-BOUTON 4$\frac{1}{2}$ h.p., 1901

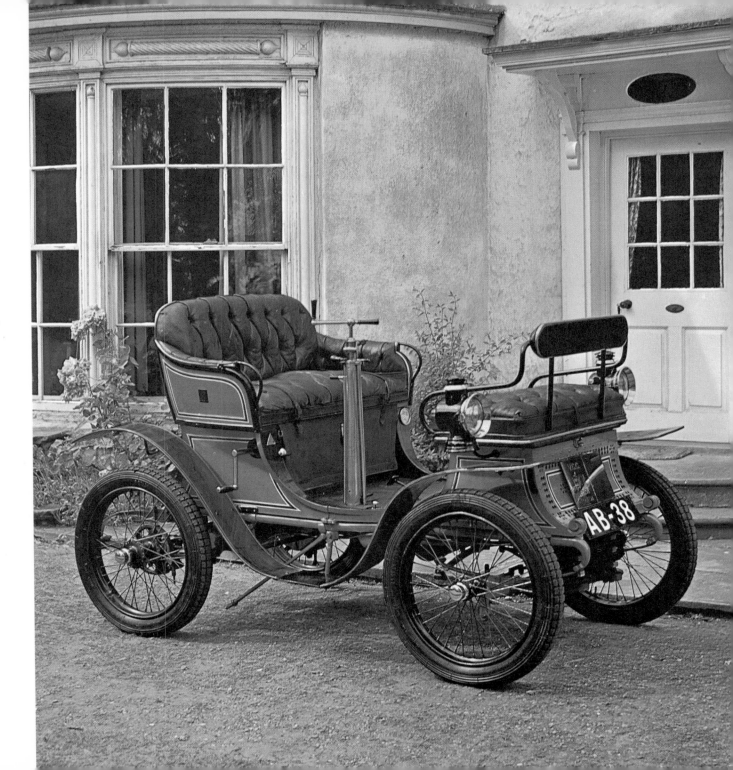

America was a slow starter in the motor industry, if only because her road system petered out into seas of mud once city limits were reached, and this Columbia is unusually big and 'European' for its period. Though the 'reach-bar' frame is typical of trans-Atlantic practice, the big vertical front-mounted single-cylinder engine is not. The unsprung back axle presented problems, but in other respects this machine, with its three-speed and reverse gearbox, wheel steering, and automatic advance and retard mechanism, is quite advanced. Interesting features (reflecting trends still to be seen in American design) are a tilting steering wheel and a minimum of control levers: only the hand-grip for the gear lever can be seen in this picture, and Columbia's carburetter needed no hand-operated air inlet control, either. Top speed was 35 m.p.h.

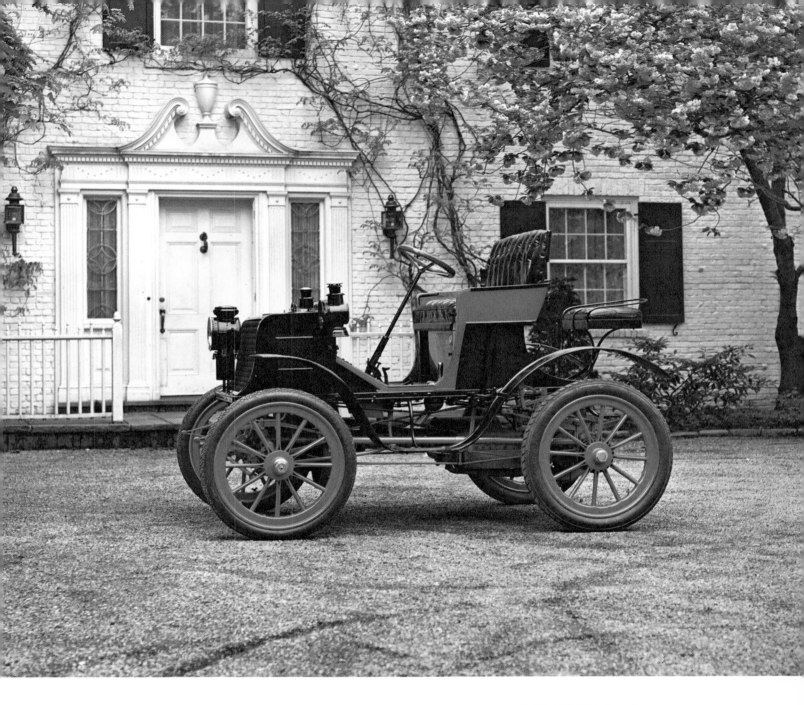

COLUMBIA 5 h.p., 1901

This Turcat-Méry design is a light racer, conclusive proof of the oft-repeated statement that every car was a sports car in those formative years. Here is a classic statement in wood and metal of French design before Mercédès influence took over—flitch-plate frame, 4-litre four-cylinder engine with automatic inlet valves, untidy tubular radiator, and low-tension magneto ignition (since altered, on this car, to high-tension). Reputedly a competitor in the Paris–Vienna Race of 1902, its touring body was made by Burlington for Lord Iveagh, and features a detachable tonneau. Top speed is in the region of 45 m.p.h.

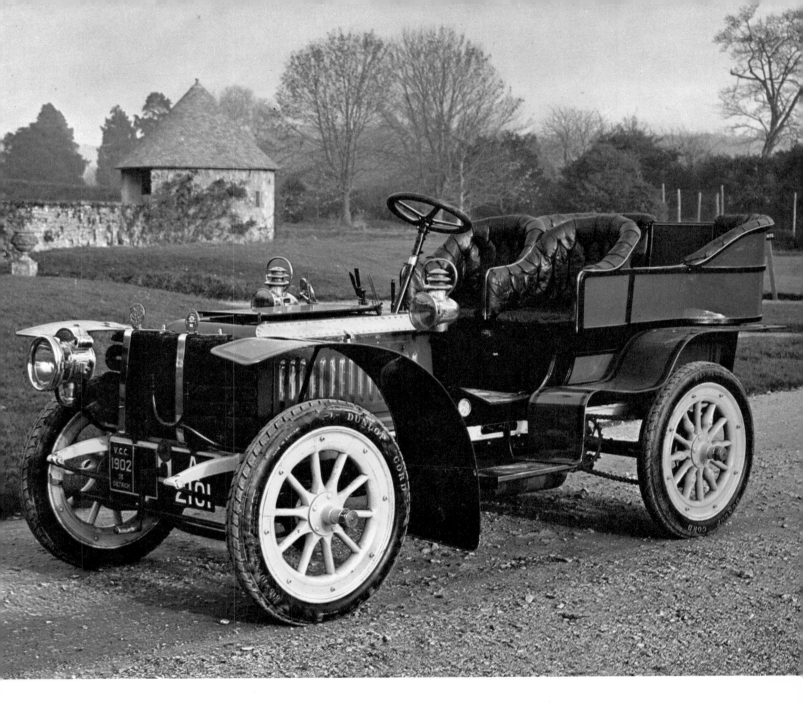

DE DIETRICH 16 h.p., 1902

Maybe the Mercédès was not quite as revolutionary as everyone said in 1901: though it would not have looked out of place 20 years later. Honeycomb radiators had been used on Cannstatt products for some years before, and so had the selective gate change. Nor were the car's other salient features—mechanically-operated inlet valves and a pressed-steel frame—unknown. The significance of Wilhelm Maybach's 'revolution' was that it set a new pattern in high-performance machinery, and within a year or two many competitors—Rochet-Schneider in France, F.I.A.T. in Italy, Martini in Switzerland—had followed suit. The 9.2-litre four-cylinder '60' of 1903 was expensive to buy (£2,200 for a chassis), and expensive to maintain, especially in tyres, but in return for this one got 70 m.p.h. where permitted by law, remarkable flexibility, and a close-ratio gearbox.

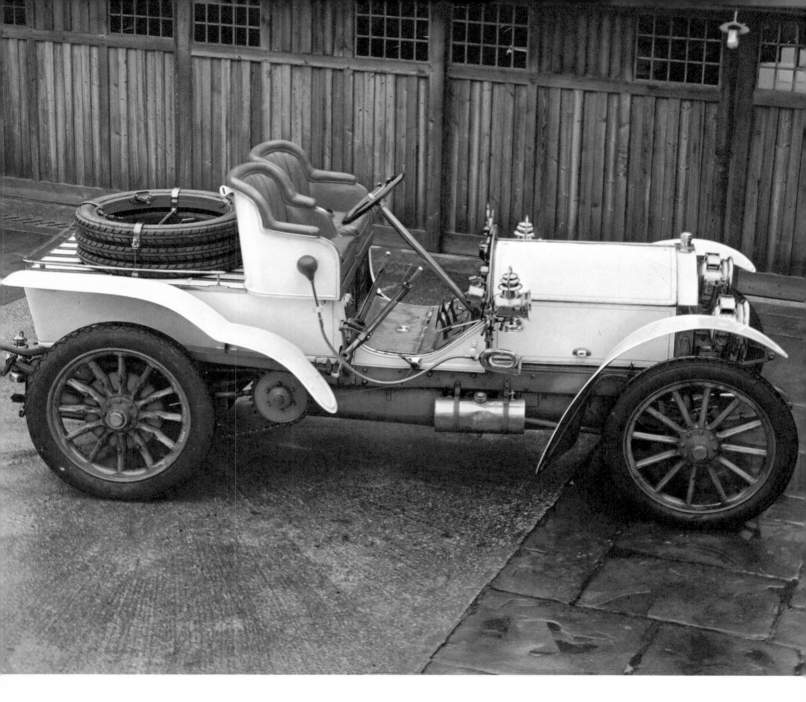

MERCÉDÈS 60 h.p., 1903

In 1905 it was already admitted that 'for balance of reciprocating and revolving parts, the three-cylinder engine has not been proved to be equal to the four', in spite of which there was a brief vogue for this type of unit. Vauxhall, who had already made their name with a single-cylinder *voiturette,* marketed this 1.4-litre offering on otherwise conventional lines, with mechanically-operated inlet valves, three-speed gearbox, half-elliptic springing, and side-chain final drive. It was reasonable value at £200. Though an underslung tubular radiator is still used, the genesis of the famous Vauxhall flutes can be descried on the top of the bonnet.

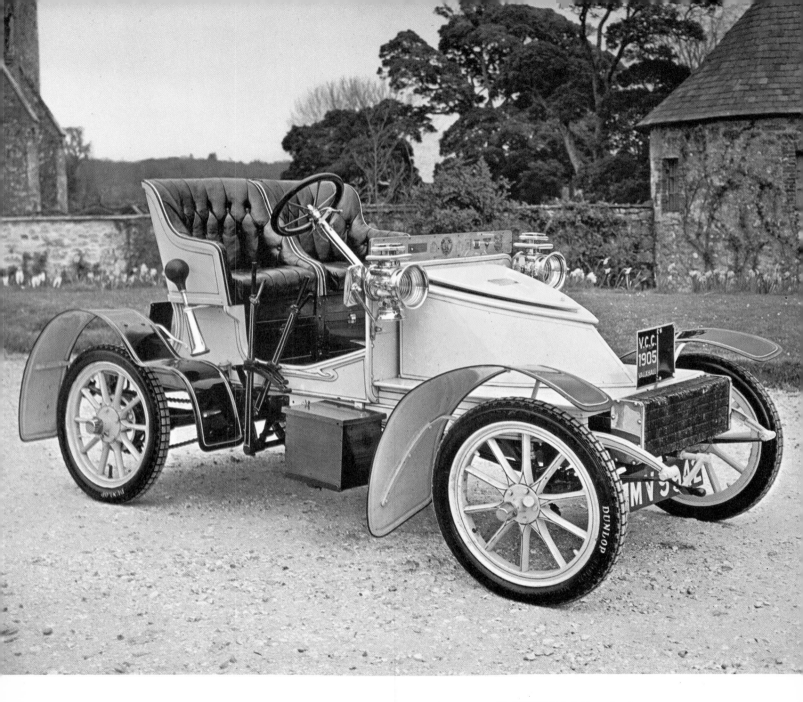

VAUXHALL 7/9 h.p., 1905

If the Mercédès carries the indelible tag 'revolutionary', the Renault is branded with equal firmness as a 'conservative' design, if only because what Renault's designer Viet laid down in 1904 still made sense 10 and more years later. The combination of dashboard radiator and under-tray conferred accessibility, excellent dust-sealing, and a degree of cockpit heating, while Renault's direct-drive, jointed propeller-shaft and sprung, gear-driven axle had been a feature of his cars from 1898. Maybe the quadrant change was getting a little barbarous by 1914, but this handsome 4.4-litre town-carriage with English coachwork offers the impressive statistics of 18 m.p.g. and 50 m.p.h.; the latter must be used with discretion on heavily cambered roads with an equipage eight feet tall.

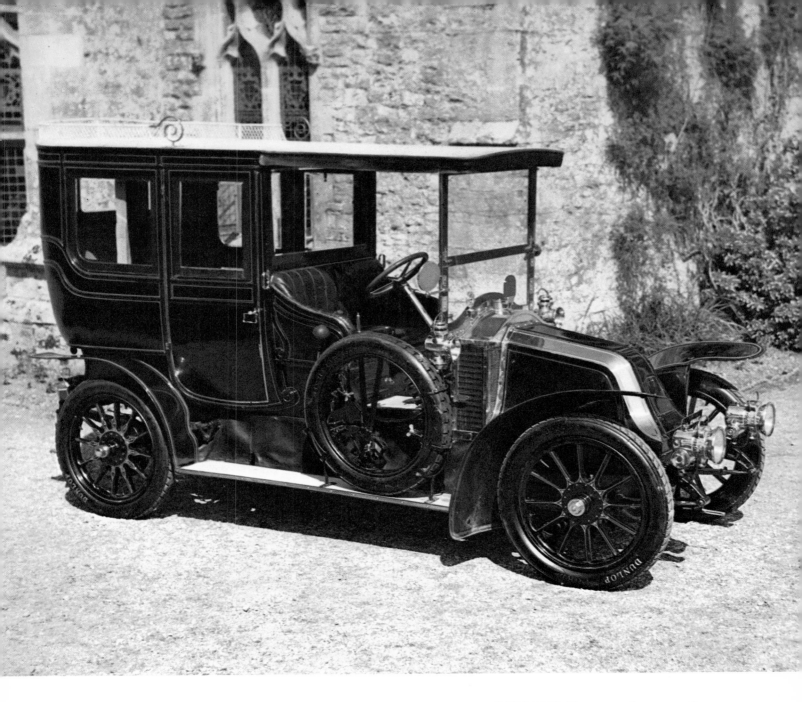

RENAULT 20-30 h.p., 1906

With only a 1,000-kilogram weight limit to govern racing-car design, the standard procedure was to cram as large an engine as possible into a light frame. If the end-product is less than happy on a modern circuit, its big, lazy power unit is charmingly flexible, and this Itala has all the advantages of a 1.43:1 top gear—85 m.p.h. at 950 r.p.m., and a theoretical 110 m.p.h. at peak revs (1,200). The big i.o.e. four-cylinder engine has a capacity of $14\frac{1}{2}$-litres—in other words, each 'pot' has a greater swept volume than a modern twin-cam. Jaguar unit. Unusual for the period is the use of shaft drive rather than chains. This is almost certainly the car used by Cagno to win the 1907 Coppa Velocita at Brescia.

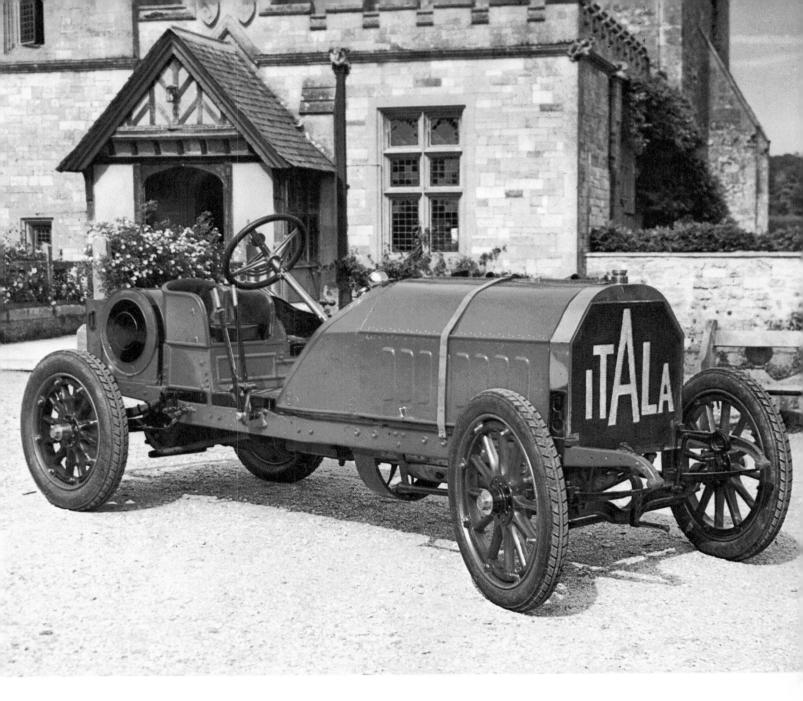

ITALA 120 h.p., 1907

By 1908 touring-car design had dropped into a groove, albeit a splendid one. This the productions of the Lanchester brothers never did, being designed as entities and not as mere agglomerations of machinery. The lever steering was still present: the oversquare 2.4-litre o.h.v. engine sat between driver and front passenger, where it wasted no space. The epicyclic preselector gearbox eliminated crude noises, while the wick carburetter was simplicity itself. Brakes were of self-adjusting, multi-disc type, running in oil. Silent worm drive and long cantilever springs added up to a highly individual specification, and owner-loyalty ran high. Alas, it was not matched by director-loyalty, and by 1915 Lancunians sat behind long bonnets like any other driver. By 1924 the smaller cars had 'crash' gearboxes as well . . .

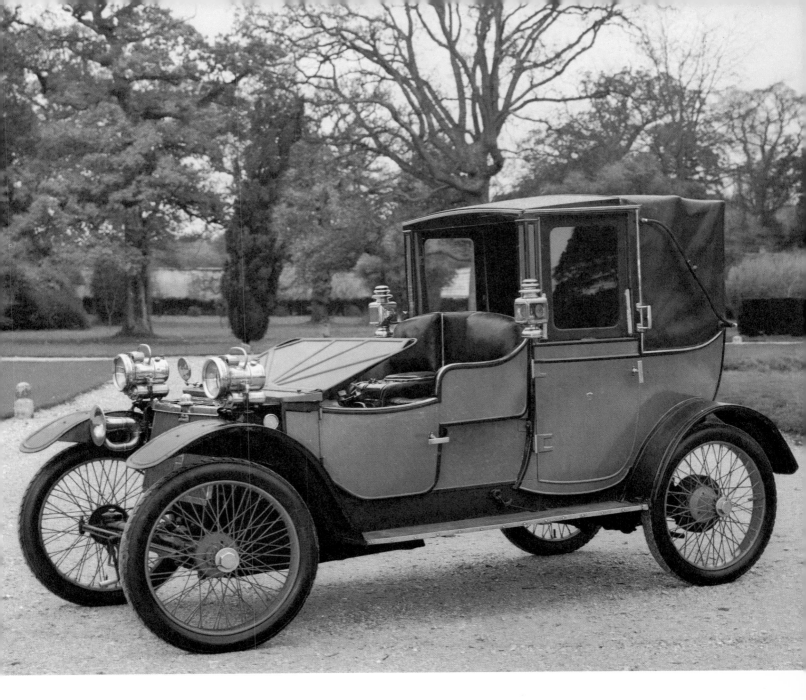

LANCHESTER 20 h.p., 1908

Perhaps the best-remembered feature of this early sporting *voiturette* was the independent front suspension by transverse spring and vertical wheel guides, of which Maurice Sizaire observed nonchalantly: 'I just designed it that way.' Unquestionably the car was simple: power came from an overhead-inlet long-stroke 'single' inspired by *voiturette* racing rules which favoured few 'pots' and stroke-bore ratios verging on the fantastic. There was no conventional gearbox, but a propeller shaft with three pinions at its rearward end which could be meshed in turn with a row of teeth on the crown wheel. The complete car weighed 14 cwt, and offered 45 m.p.h. for only £225. Unfortunately, 'singles' were becoming too rough even for the lower echelons of the market, and though the makers religiously kept it a two-seater, its popularity did not last.

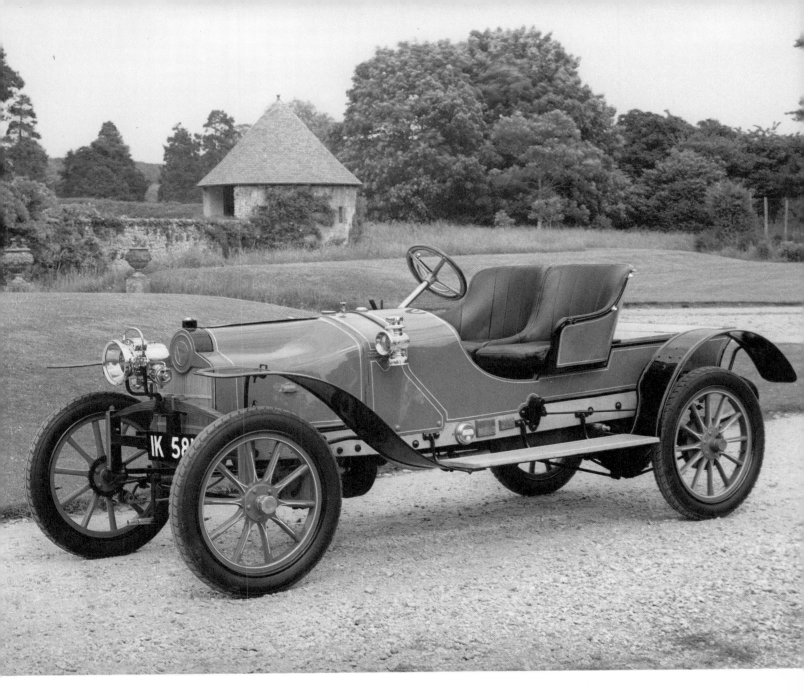

SIZAIRE-NAUDIN 12 h.p., 1909

'One never drives a Delaunay', said the great Fernard Charron, 'It simply isn't done.' But the best people, from the Tsar of all the Russias downward, were driven in them. As befitted the product of a leading firm of boiler-makers, it was superbly finished, and design features included pressure lubrication, a full undertray for engine and gearbox, and a round radiator to remind the public of the car's origins. This Type-HB is a 4.4-litre side-valve six (the firm made over 3,500 six-cylinder machines between 1908 and 1916) with four-speed gearbox, and the Burlington landaulette bodywork is fitted with a delectable 'car communicator' whereby Madame could attract the chauffeur's attention without recourse to a speaking-tube. A chassis cost £580, which was not excessive.

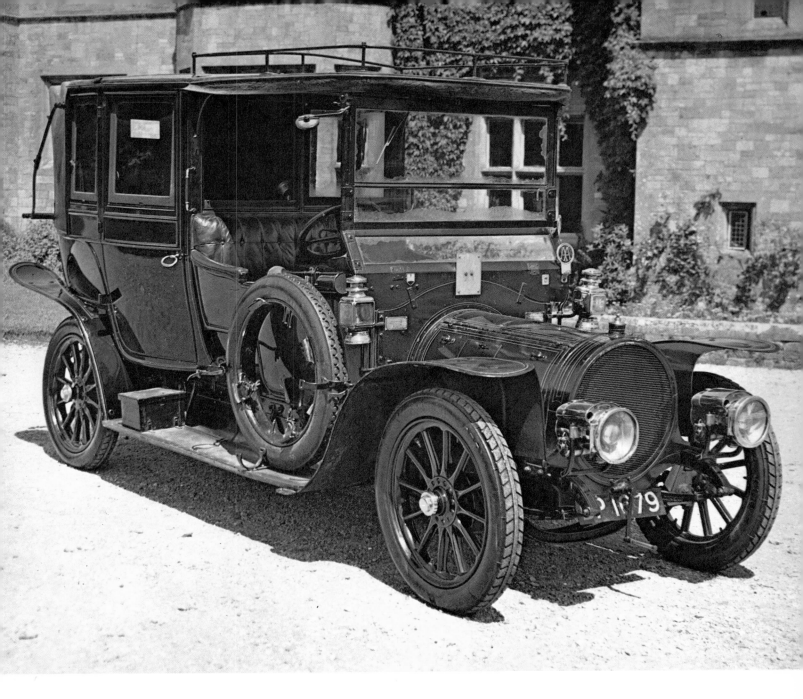

DELAUNAY-BELLEVILLE 15CV, 1911

Sports-car evolution owes a great deal to the pre-1914 road rallies held in Germany and Austria—the Herkomer and Prince Henry Trials, and the original 'Alpine'. The 1910 Prince Henry event was dominated by the Austrian Daimlers, the actual victor being designer Ferdinand Porsche at the wheel of his newest creation, the 5.7-litre '27-80' with inclined valves actuated by an overhead camshaft, dual magneto ignition, and a tulip-shaped open sports body. In its original form it had side-chain drive, and top speed was quoted as 88 m.p.h. At £995 complete it was a 'must' for young bloods: this later shaft-driven car has touring bodywork by Salmons—a little less flamboyant than the factory style, but easier on the eye.

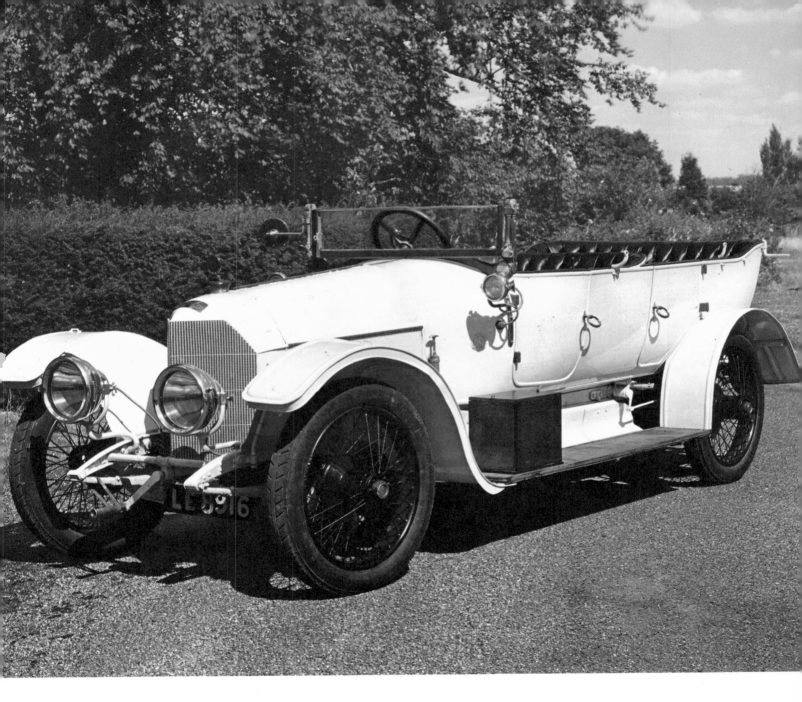

AUSTRIAN DAIMLER 27-80 h.p. 'PRINCE HENRY', 1912

When Zuccarelli won the 1910 *Coupe des Voiturettes* with a four-cylinder Hispano-Suiza, it marked the end of the 'big singles' such as the Sizaire-Naudin. The production 'Alfonso', named after its manufacturer's most illustrious client, was not the world's first sports car, nor was it what one would nowadays term a *voiturette,* its immensely long-stroke (100 × 180 mm) T-head engine displacing 3.6-litres. But it was an excellent all-rounder, especially with the four-speed gearbox fitted from 1913: with 64 b.h.p. under the bonnet it was good for 70 m.p.h. and, as war-time owners found out, it consumed petrol at the frugal rate of 23-26 m.p.g., and was light on tyres.

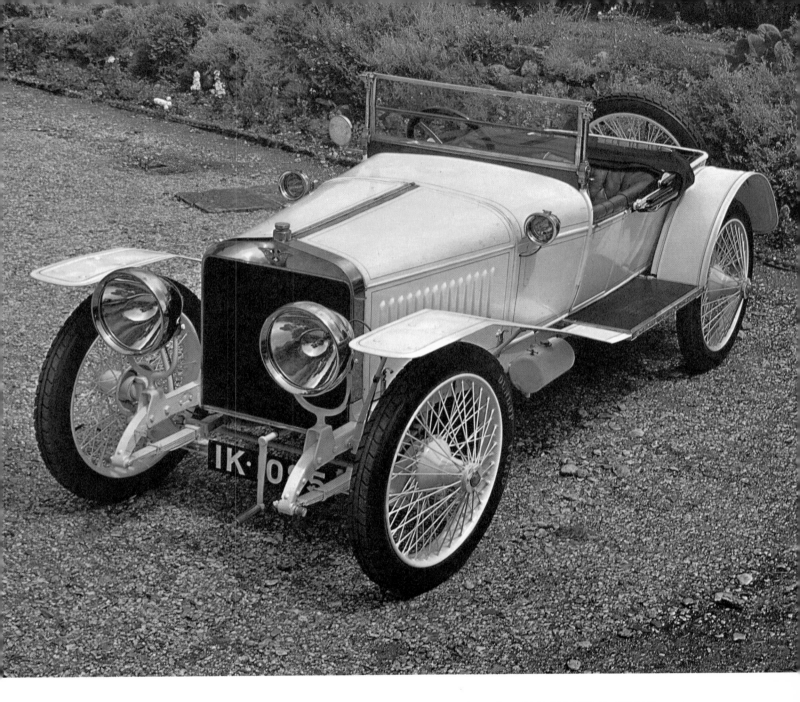

HISPANO-SUIZA 'ALFONSO XIII', 1912

To the Englishman the D.F.P. is famous because the Bentley brothers handled it in London, and added aluminium pistons to the recipe to make it perform. In fact, MM. Doriot, Flandrin and Parant were not particularly interested in performance, and this '10-12' may be regarded as a typical lady's runabout of the period, with straightforward s.v. 1.6-lire four-cylinder monobloc engine, cone clutch, three-speed gearbox, magneto ignition, and bevel final drive. A transmission foot-brake, fixed wood wheels with detachable rims, and acetylene lighting completed a presentable, but not outstanding £245-worth, which served one lady owner for a quarter of a century before ending its working life as power for a saw bench.

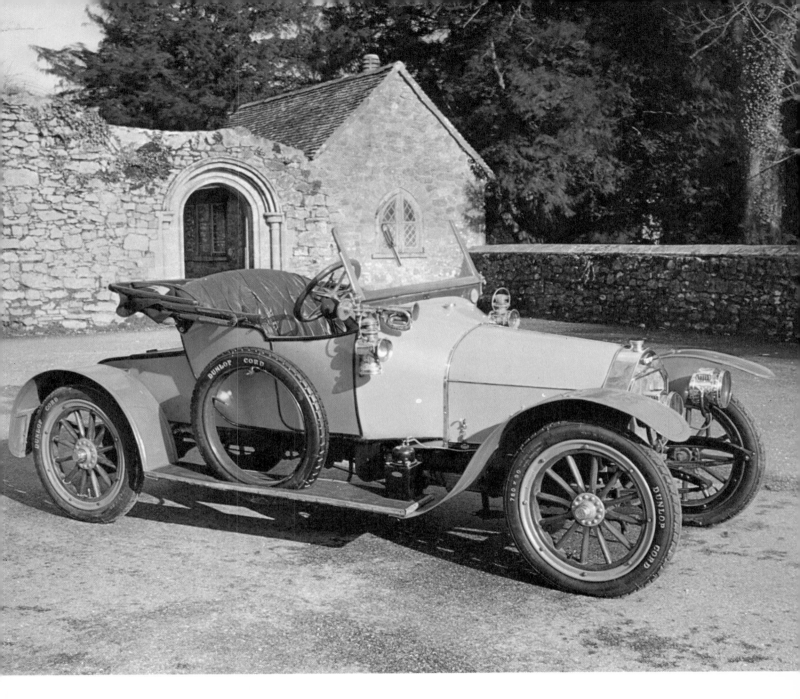

D.F.P. 10-12 h.p., 1913

To the modern American, a sports car is an imported car. It was not ever thus, and one of the side-effects of Henry Ford and the rise of mass-production was a short-lived generation of desirable sporting machinery, distinguished by an excellent power-to-weight ratio, and minimal appointments: two bucket seats, a large petrol tank, and a monocle windscreen. The Mercer's 5-litre four-cylinder T-head engine and three-speed gearbox were carried in a sub-frame, output was 58 b.h.p. at 1,700 r.p.m., and the factory claimed a mile in 51 seconds. Road-holding was excellent, and in 1913 the cars were given an extra forward ratio. Production never exceeded 500 vehicles a year: as by no means all of these were Raceabouts, the survivors are now worth their weight in uranium.

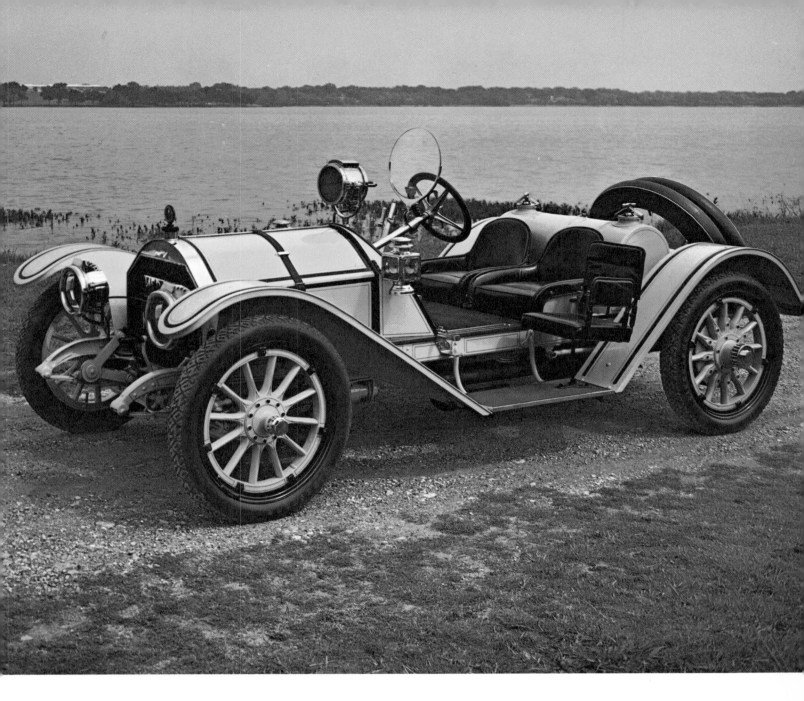

MERCER 35-J RACEABOUT, 1913

A French chassis married to English bodywork, this model typifies the better class of touring car in the idiom of 1914. There are no unconventional features—the engine is a 4 1-litre side-valve monobloc affair, the gearbox has four forward speeds, and ignition is by magneto. An 11ft. 3in. wheelbase gave plenty of room for the body, while the flowing line from windscreen to radiator cap and the detachable wire wheels suggest 1924 rather than a decade earlier. The electric lighting and starting fitted to this car cost £85 extra, and even if Rolls-Royce were unhappy about the obvious derivation of the radiator, owners could still cruise comfortably at 45 m.p.h. for only £745.

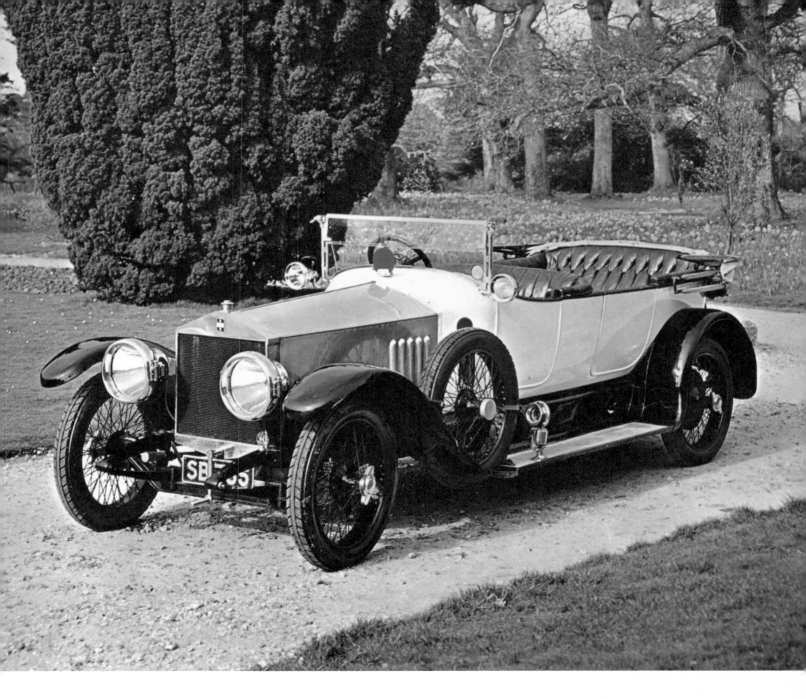

SIZAIRE-BERWICK 20 h.p., 1914

When a car changes the habits of a generation to the tune of 15 million units sold, it leaves a trail of folklore behind it, and the main task of 'Lizzie's' chronicler is to sort out the fact from the fancy. The Ford certainly offered the most for the money: its 2.9-litre s.v. monobloc engine had a detachable head, and the foolproof two-speed pedal-controlled gearbox, if archaic to the point of comedy by 1927, was regular American practice in 1908, when the first cars left the works. The transverse springing gave a peculiar ride, the brakes were more than dubious, and the ingenious flywheel-magneto ignition had its trials. This example carries British-built landaulette coachwork, hence the deviation from the (by then) uniform black; but even in England a standard model could be yours for £135 in 1915.

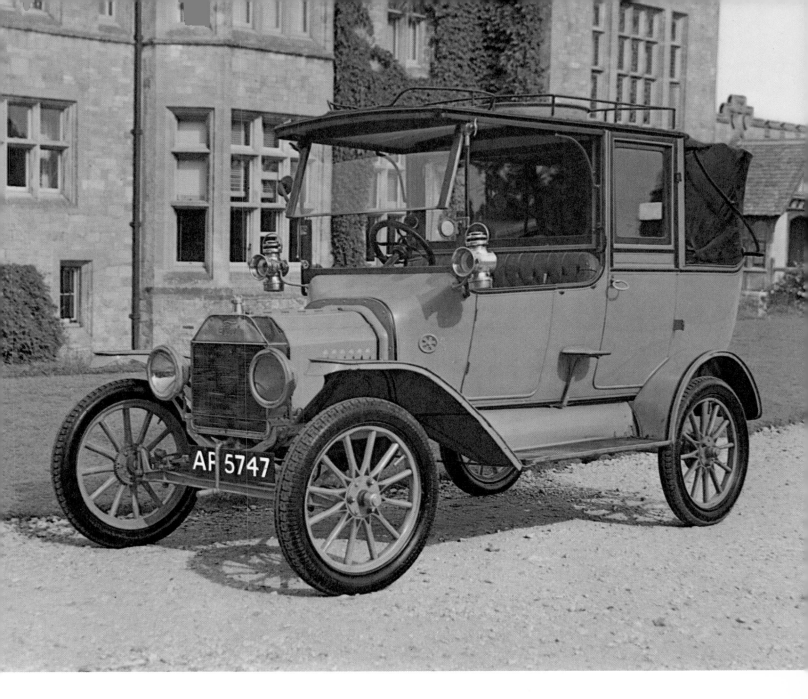

FORD MODEL-T, 1915

The influence of war-time aircraft practice did not spread generally to touring-car design immediately after the armistice, and the principal developments to be seen in the 3.7-litre Crossley are the detachable cylinder head and the standardisation of full electrical equipment. The four-speed gearbox is still separate from its engine, the unjustly-despised cone clutch was retained, and the footbrake still worked on the transmission. Springing was semi-elliptic all round, and four-wheel brakes were not even an option until 1924. Originally this car wore high-pressure tyres and steel artillery wheels: 60 m.p.h. was available. With such dignified looks, it is easy to understand why the Crossley was considered correct pro-Consular wear in the 1920s.

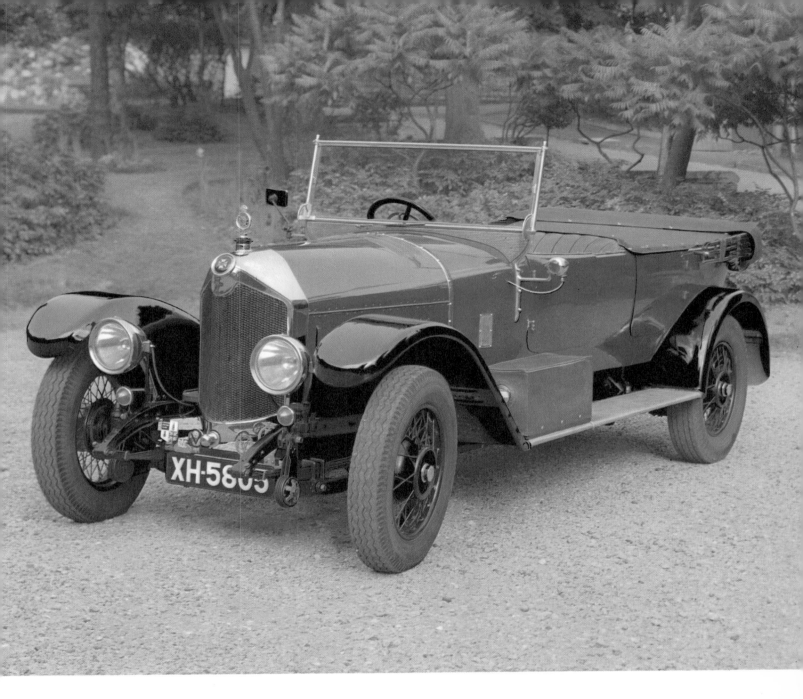

CROSSLEY 19.6 h.p., 1921

While others offered mildly re-worked editions of their 1914 cars, Marc Birkigt took advantage of his aero-engine experience during the War, and the overhead-camshaft 6.6-litre six-cylinder Hispano-Suiza was the most advanced model on general sale in 1920, with servo-assisted four-wheel brakes and dual coil ignition. 135 b.h.p. under the bonnet meant a safe 85 m.p.h., and three forward speeds sufficed. Even if one was always concious of superior machinery at work, the car remained the novelist's dream from its handsome *cigogne volante* mascot to the elegant tail of its torpedo coachwork. The enlarged 8-litre 'Boulogne' of 1924 would comfortably exceed 100 m.p.h., and looks its best cloaked with this splendid *bateau* body in tulip-wood.

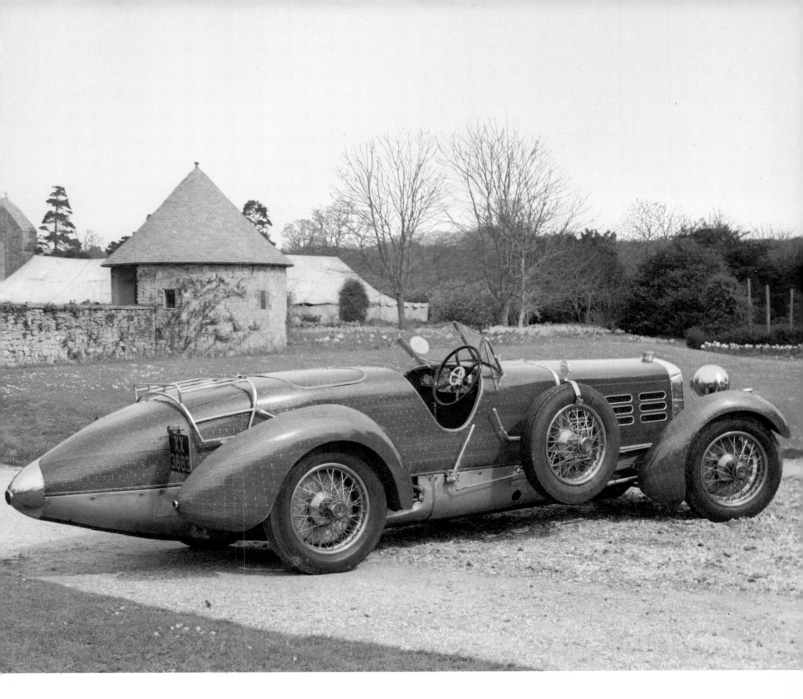

HISPANO-SUIZA 'BOULOGNE', 1924

The Model-T Ford put America on wheels: in England the Bullnose Morris assumed a similar role. Starting in 1913 as a better-than-average assembled car, it rode out the slump of 1921 because W. R. Morris slashed his prices in the face of a prevailing upward trend; when the profits started to roll in, he used them to absorb his component suppliers and thus become a true manufacturer. His reward was a sale of 54,000 cars in 1925. Despite rumours that the Morris's brakes were deliberately made to squeak as an identification-signal, there was nothing unusual about the breed, except its sweet wet-plate clutch, and its easy ball-change three-speed gearbox. But how many of us cut our motoring teeth on £5-worth of 'Bullnose' before they started to become status symbols?

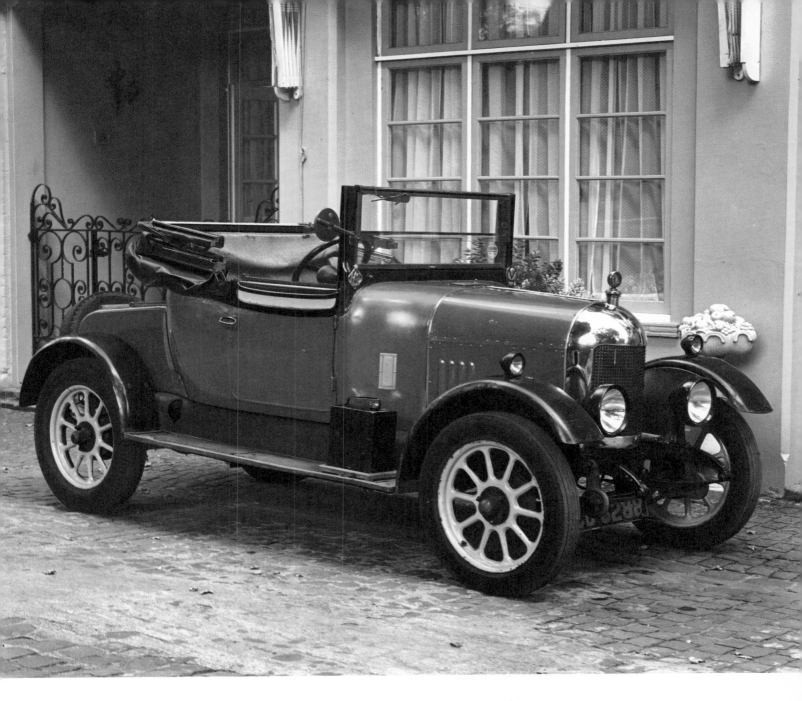

MORRIS-OXFORD 14-28 h.p., 1924

The makers called the '30-98' a Fast Light Touring Car, though it came about in 1913 when L. H. Pomeroy 'stretched' a 'Prince Henry' for J. Higginson to drive at Shelsley Walsh. The side-valve cars went into series production in 1919—light weight, flexibility, and an over-steer lending itself to a driver with 'good hands' made its name, as well as revealing to the initiated that an absence of effective brakes was no irretrievable handicap. Even in later form with hydraulics the stopping power was never of the best. The 'OE' model with overhead valves came in 1923, and this is the boat-bodied 'Wensum', appositely named after the river in which Vauxhall driver A. J. Hancock kept his boat. Possibly the greatest 'driver's car' of its era.

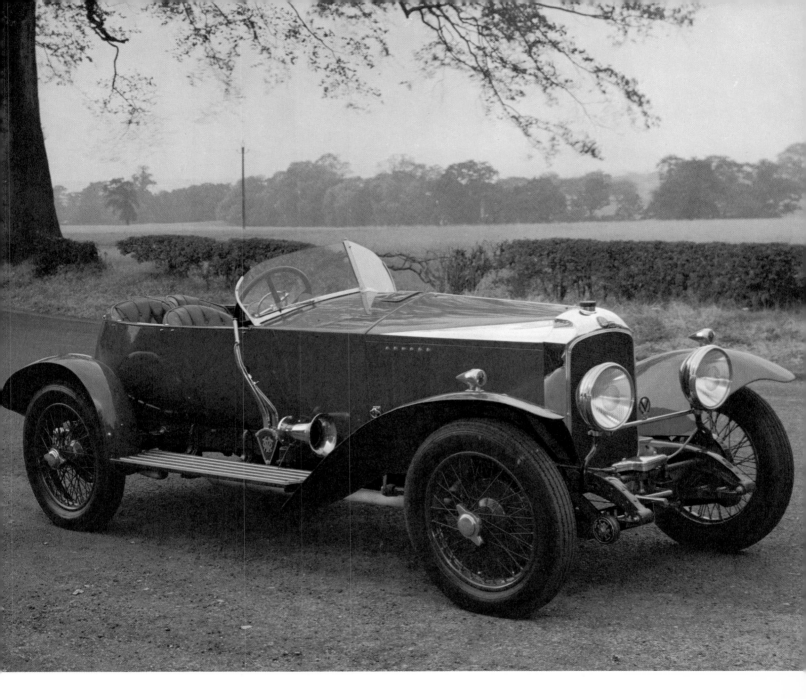

VAUXHALL 30-98 h.p., 'WENSUM', 1924

Here was the ideal all-round sports car, not only for those with £500 to spend in the 1920s, but for the modern Vintage enthusiast who values simplicity and reliability allied to a respectable performance. A straight-forward o.h.v. pushrod 'four' of 1,496 c.c. or 1,645 c.c., the '12-50' weighed 19 cwt in two-seater form, and offered over 70 m.p.h., with 60 available on the close-ratio third gear. The handsome polished-aluminium 'duck's back' with undercut tail was the most sporting style in the catalogue, and if the Alvis was a little too heavy in chassis and body alike to compete against Frazer Nash or Bugatti, it was light on petrol and easy to maintain.

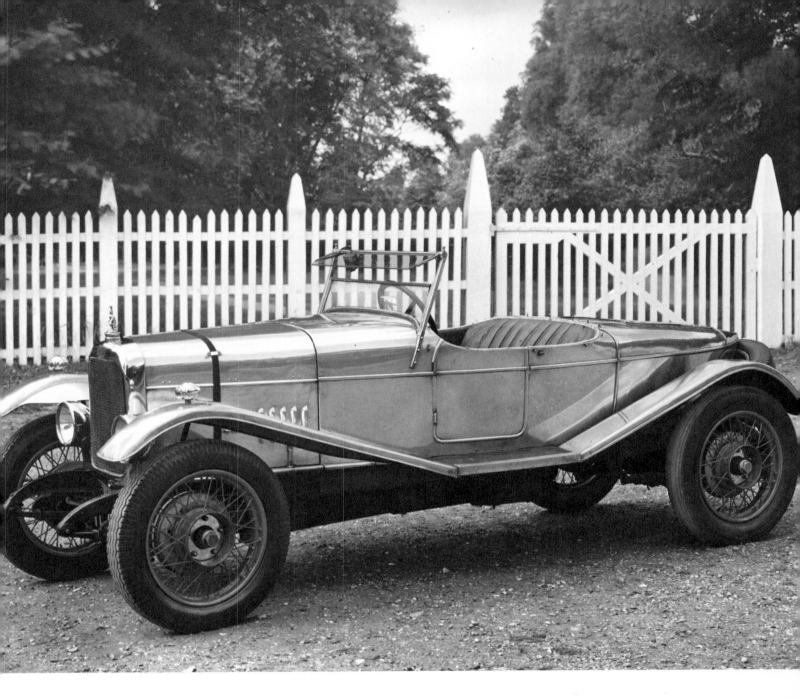

ALVIS 12-50 h.p., 1925

Strictly a touring car in its native land, (where long-chassis versions spent the evening of their lives as taxicabs), the 'Lambda' combined surefooted handling and steering of immense precision with an excellent ride, the result of sliding-pillar i.f.s. Further, there was unitary construction of chassis and body, and plenty of room for the passengers thanks to the use of a narrow-angle o.h.c. Vee-4 engine, with block only 22 inches long. In nine Series the 'Lambda' grew up from 2.1-litres and 49 b.h.p. to 2.6-litres with 69 b.h.p.; but while 80 m.p.h. remained the top limit in standard form, it was a car that was hard to catch.

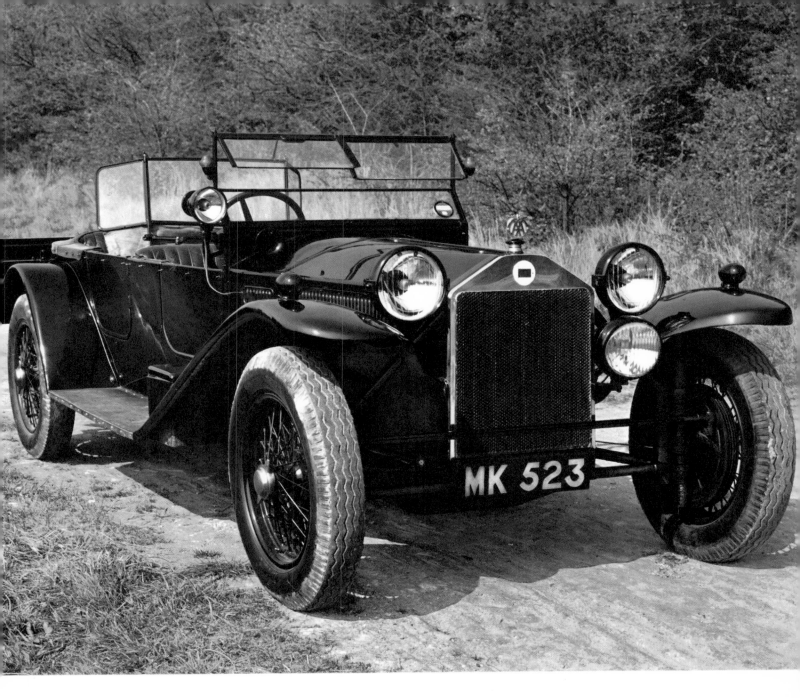

LANCIA 'LAMBDA', 1925

Versatility personified—this V-12 based on Sunbeam's six-cylinder 2-litre G.P. car was the last machine with normally-dimensioned engine to take the World's Land Speed Record. Incredibly, it also held the standing-start mile record, competed in Grand Prix road races, and collected Monza and Brooklands Outer Circuit lap records in the course of its career. 306 b.h.p. from 4-litres was in itself creditable, and Segrave's 142 m.p.h. at Southport required little more than threequarter throttle. Later this car and its sister machine were rebuilt by Sir Malcolm Campbell, and raced by Kaye Don at Brooklands. The Sunbeam, with some of its less felicitous modernisations now sorted out, is still active in Vintage racing.

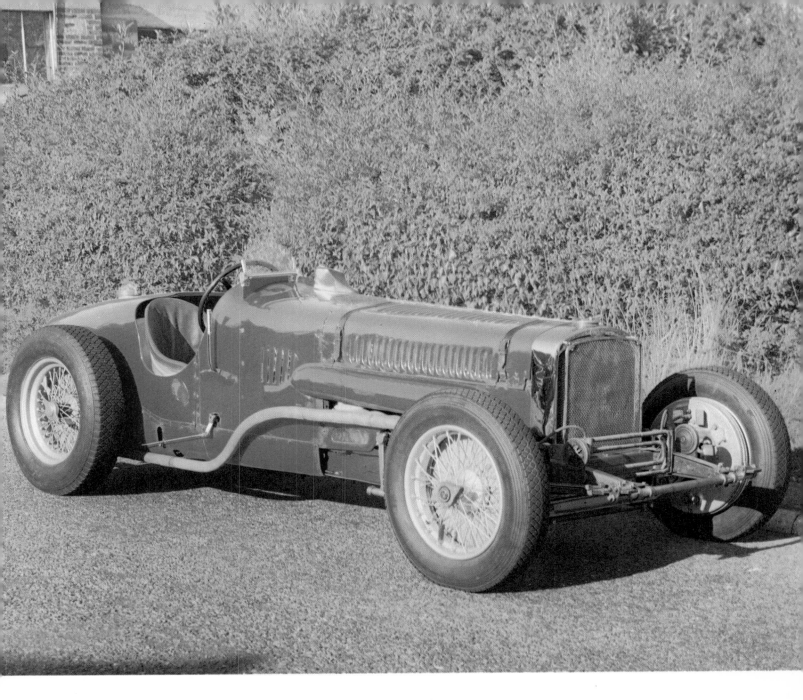

SUNBEAM 4-LITRE V-12, 1925

From the ashes of the cyclecar boom there arose in France a generation of small sports cars. Take a light chassis, a differential-less back axle, and a proprietary side-valve four-cylinder engine, cloak them in minimal bodywork with staggered seats and dubious weather protection—and the result will be a reasonable power-to-weight ratio. The Amilcar used its own 1,100 c.c. power unit, but otherwise conformed to type. Never mind if the quarter-elliptic rear springs gave a harsh ride, and the four-wheel brakes were somewhat tenuous: 70 m.p.h. and 40 m.p.g. were on tap, for £250-odd, and sports versions had full-pressure lubrication, too. This particular 'undergraduate's dream' came to an end when Amilcar, like Salmson, tried to make small luxury saloons instead. Dare we say that the tradition was carried on across the Channel by M.G.?

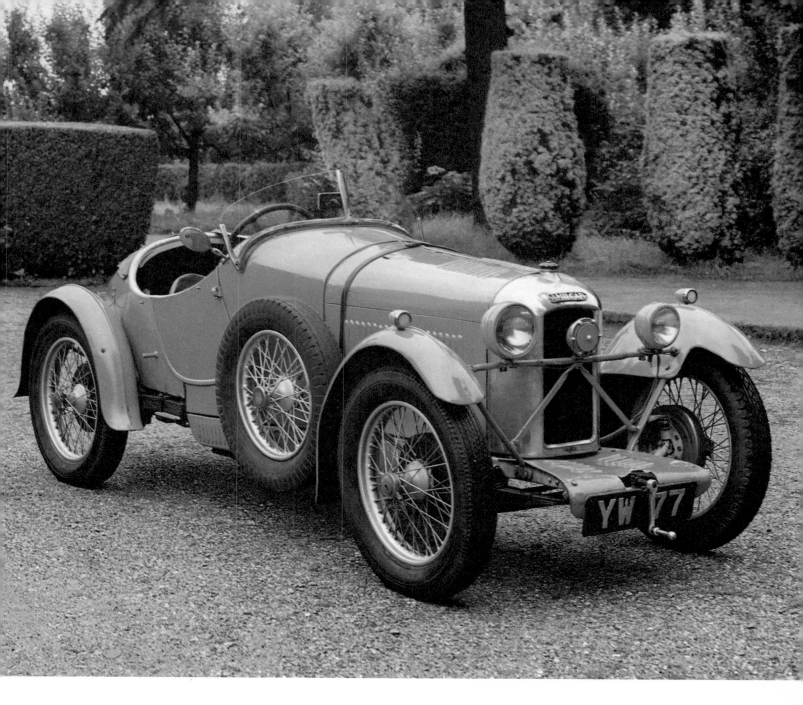

AMILCAR 4CGS, 1926

When we think of Bugatti straight-eights the Grand Prix Type 35 comes to mind, but the genesis of these lay in Ettore's first production 'eight', a 2-litre with three valves per cylinder: the limitation imposed by a three-bearing crankshaft was 3,800 r.p.m., above which one ventured at one's peril. Though hydraulic brakes were used on the first Type 30s, all-round mechanicals had been adopted by 1926, and the car differs from Type 35 in that the front axle is of conventional H-beam type. The car will exceed 75 m.p.h. The open-sided style of tourer was popular in Southern France and Italy: Bugatti catalogued Type 30 as a touring car, but in 1924 an English Court of Law ruled that it was not!

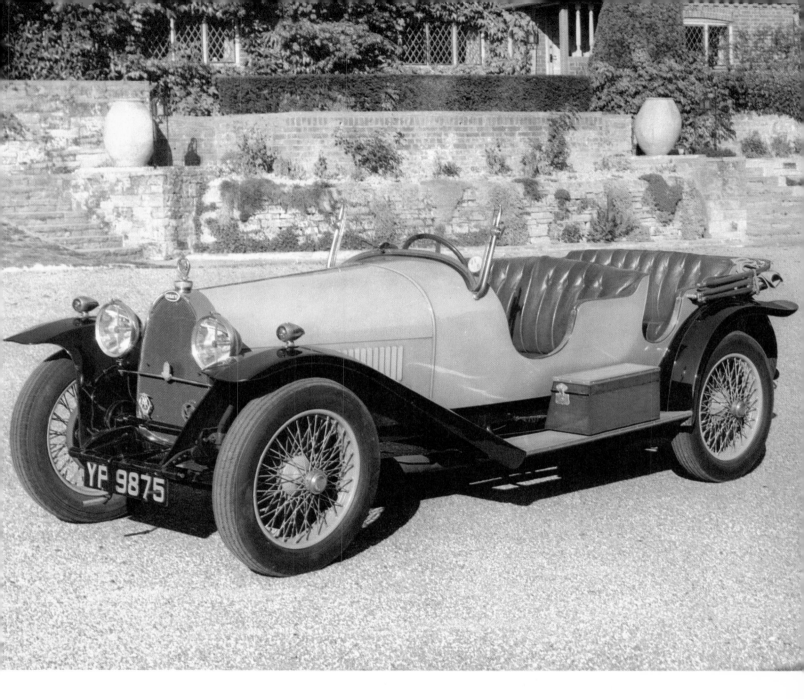

BUGATTI TYPE 30, 1926

Despite their long connection with racing and record-breaking, Sunbeam specialised in luxury touring machinery, and their only contribution to the ranks of out-and-out sports cars was the 3-litre first seen at Le Mans in 1925, when it finished second. A very advanced twin o.h.c. six-cylinder engine was used, with unit construction of block and head, and dry-sump lubrication. On 90 b.h.p. the car would do 90 m.p.h., but unfortunately the long, narrow-track chassis with its cantilever rear suspension was better suited to a tourer, and handling could be peculiar. Cracked blocks were also a problem, and for all the elegance of the open cars with cycle-type mudguards that turned with the wheels, the Sunbeam was never a serious rival to W. O. Bentley's four-cylinder models.

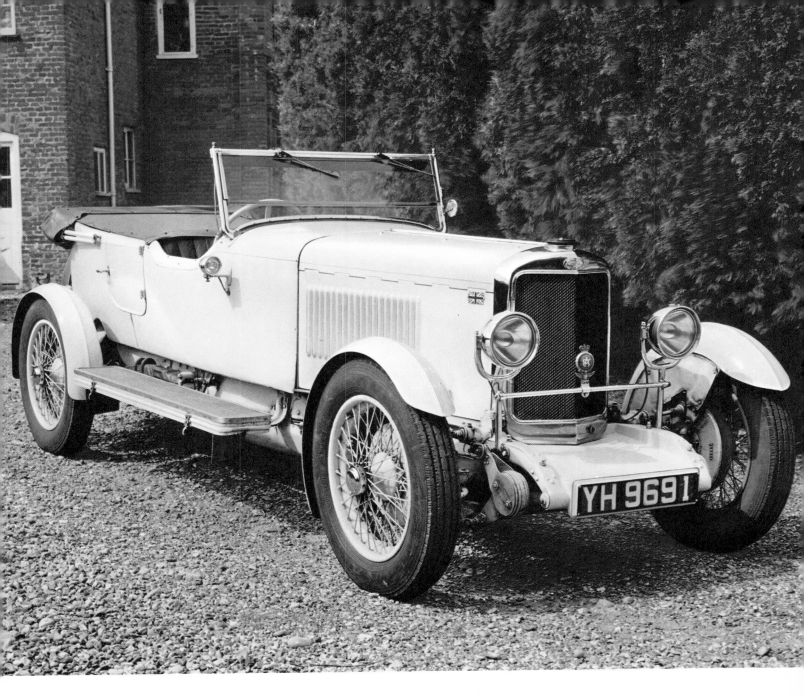

SUNBEAM 3-LITRE, 1927

Archaic though the retention of a four-cylinder engine on a big car may seem, the 4½-litre was a worthy successor to 'W.O.'s' classic 3-litre, and well merits its status as the laymen's concept of a Vintage Sports Car. With a single o.h.c. 100 × 140 mm (4.4-litre) power unit based on its predecessor, the Bentley offered a very high standard of reliability plus 90 m.p.h. in standard form, and a car of this type won at Le Mans in 1928. Almost as classic as the chassis was the fabric four-seater body by Vanden Plas with its externally-located gear and brake levers: apart from the cycle-type wings this example is in original condition.

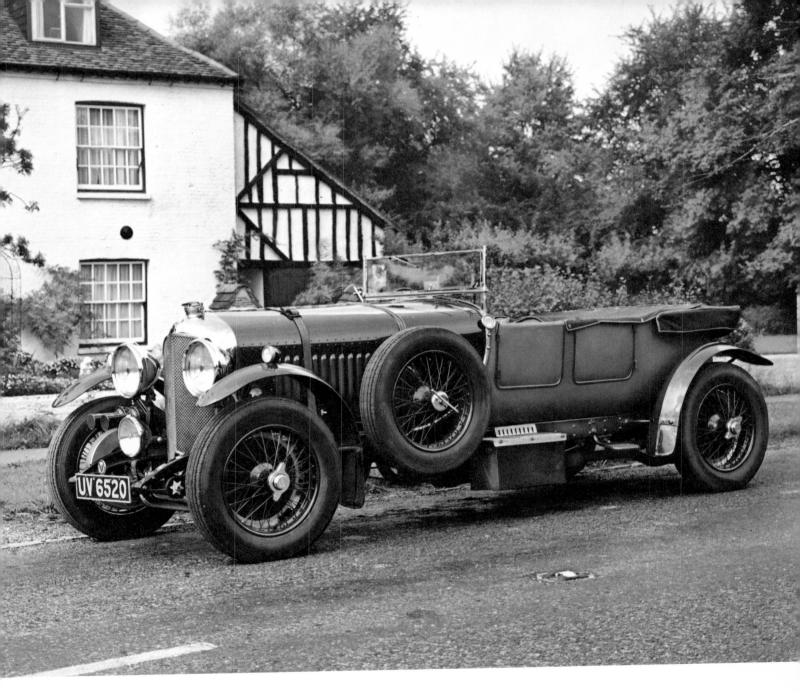

BENTLEY 4½-LITRE, 1928

From 1919 onward all Isottas used Cattaneo's o.h.v. pushrod straight-eight engine, probably the first of its type to see series production. Four-wheel brakes (which the factory had been fitting since 1910) were also standard, as was a three-speed gearbox, and suitably clad by Cesare Sala, this big Italian was as elegant as anything that came out of the Hispano-Suiza works at Bois-Colombes. Unfortunately the Isotta-Fraschini was designed to be driven in, rather than for the driver—hence it was sluggish and heavy on the hands, and invariably comparisons were drawn between the two double-barrelled giants. In 1925 came the 7.4-litre, 135 b.h.p. 8A with rather more urge, but with the Depression Isotta went over to aero-engines, a few years before Hispano-Suiza's similar abdication.

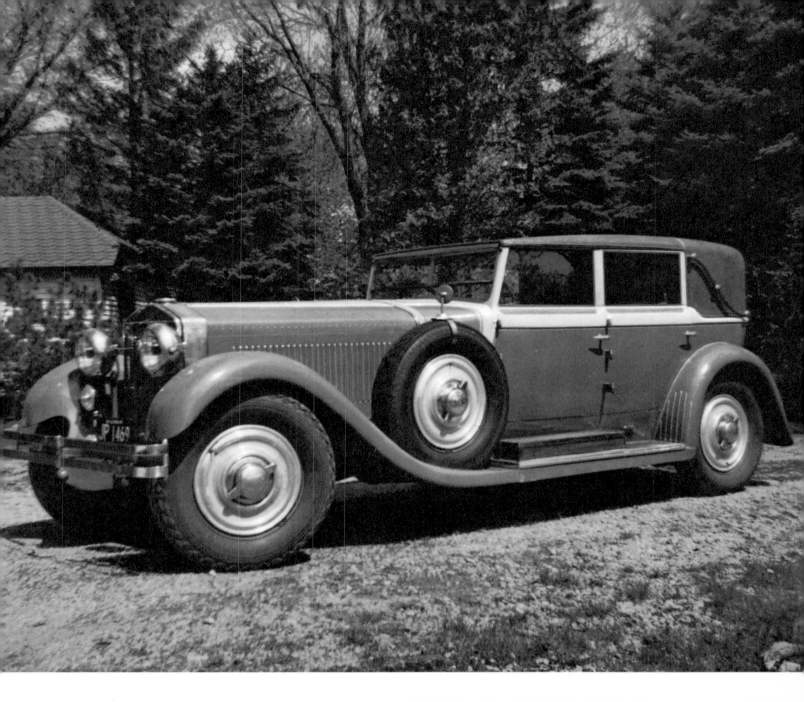

ISOTTA-FRASCHINI TIPO 8A, 1929

If visually and audibly the Bentley symbolised the bulldog breed, it had a worthy Teutonic rival in the 'SSK' from Stuttgart. A Ferdinand Porsche creation, the 'SS' series represented the ultimate development of a line of massive six-cylinder o.h.c. cars with Roots-type double-vane blowers, intended to give brief bursts of dramatic acceleration, and engaged by depressing the 'loud pedal' beyond its normal travel. Liberal use of light alloys kept the weight down to 47 cwt for a tourer on this 7.1-litre chassis, and with a 2.7:1 top gear one could cruise fast on a modicum of revs. The brakes were not the car's strongest suit, and the fuel consumption was daunting, but the sound of the blower cutting in under a railway bridge is one to be savoured.

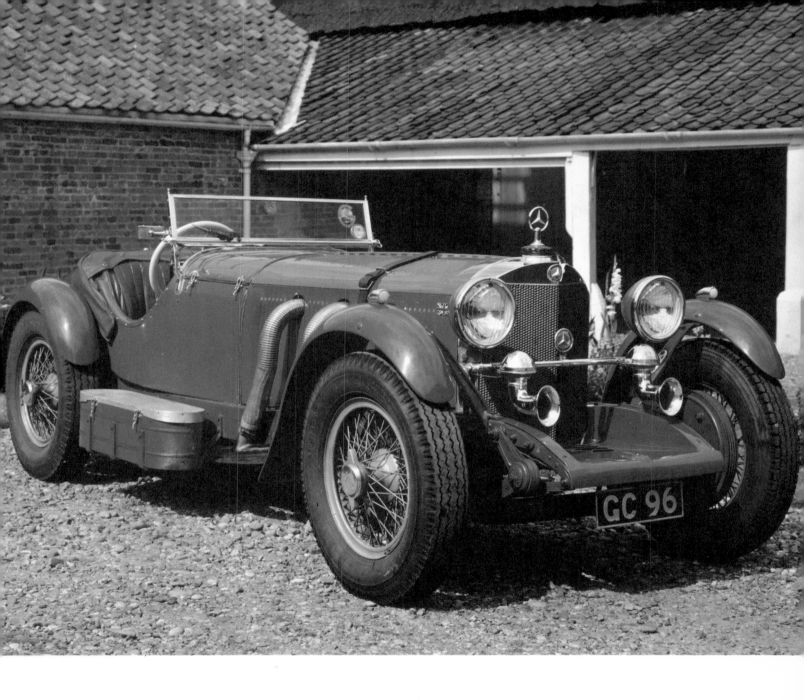

MERCEDES-BENZ 'SSK' 38-250 h.p., 1929

The 'Lambda' had been a fast and moderately-priced tourer, but Lancia, like others on the eve of the Great Depression, came up with a true luxury car in the modern idiom. Inherited from the earlier model were both the i.f.s. and the narrow-angle overhead-camshaft Vee engine (in this case a 4-litre 'eight'), but a separate, electrically-welded frame allowed the specialist coachbuilders a greater scope, as witness this Pinin Farina cabriolet body. Despite a weight of some $2\frac{1}{2}$ tons, the top-gear performance was excellent, and 75 m.p.h. was on tap. Though the model failed to impress the American market for which it was originally intended, some 1,600 were sold up to 1932, later models receiving servo assistance for their cable-operated brakes.

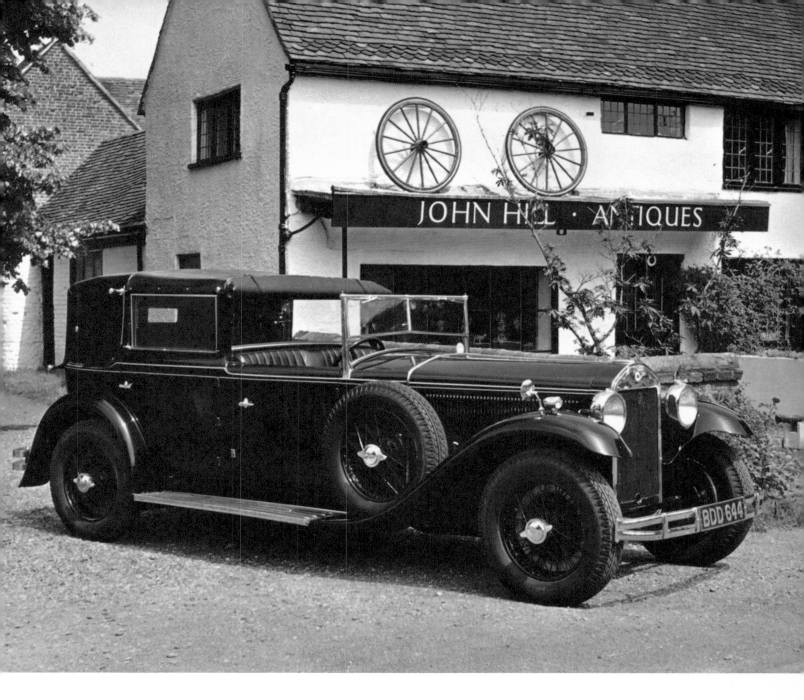

LANCIA 'DILAMBDA', 1930

America's pre-eminent luxury car in the inter-war period, Packard sold over 48,000 cars in 1929, despite a range consisting solely of big straight-eights priced from $2,435 upward. This type had been introduced in 1923 and survived until 1939. Four-wheel brakes were standard from the start, and a refusal to subscribe to annual styling face-lifts allowed the makers to issue a used-car catalogue for those who could not afford to buy new. The rare 734 with boat-tail speedster body and four-speed gearbox (only 150 were made) had a high-compression version of the 6.3-litre engine giving 145 b.h.p.: on a 3.3:1 back axle 100 m.p.h. was available in turbine-like smoothness.

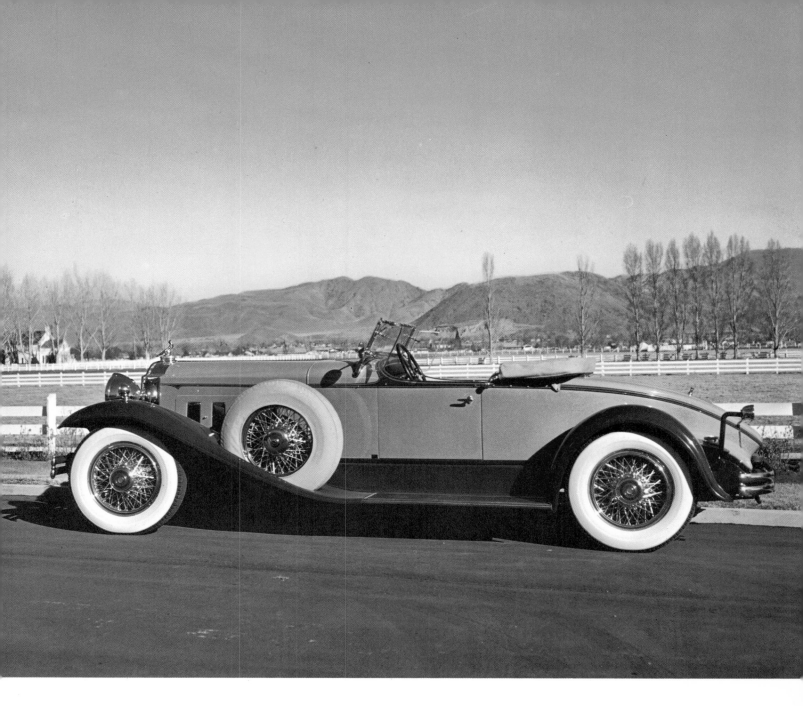

PACKARD '734', 1930

Here is a ferocious and noisy small 'six'. The ride is hard, the 95 b.h.p. twin o.h.c. blown engine whines savagely, and the straight-cut gears in gearbox and pinions have a music all their own. Alfa steering has been described as 'seat-of-the-pants', and this is still one of the fastest and most satisfying ways of getting from A to B over winding roads, though one pays for the privilege in terms of 12-15 m.p.g. Underbonnet finish is a delight, and the traditional two-seater bodywork by Zagato— though not for the sybarite in wet weather—looks exactly right. Unfortunately it didn't when recreated on a modern Alfa-Romeo chassis in the 1960s.

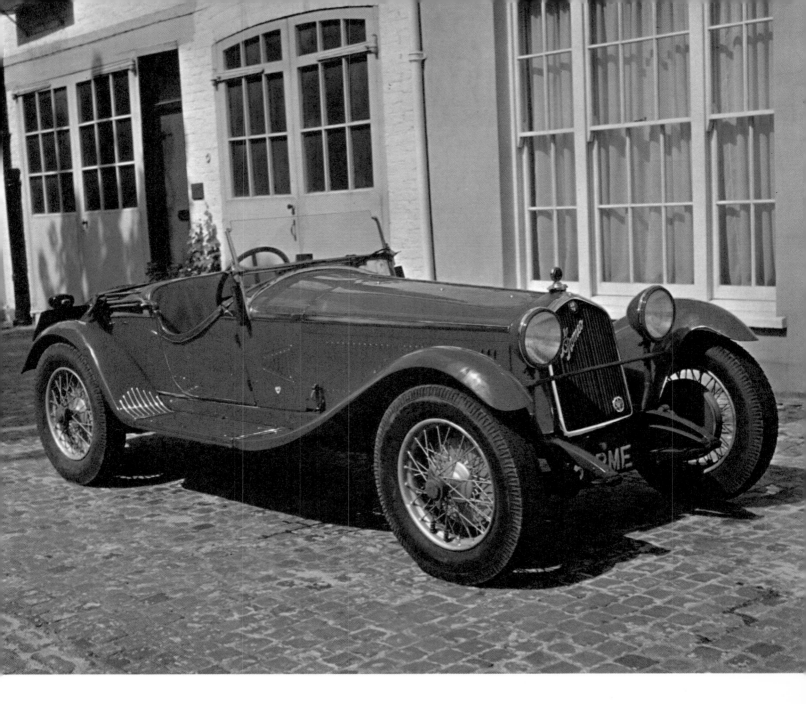

ALFA-ROMEO 1750GS, 1931

When Sir Oliver Lyle and Noel Macklin launched the Invicta in 1925, their idea was to combine the top-gear performance of American imports with British quality workmanship. Strictly an assembled machine, it used push rod six-cylinder Meadows engines in increasing sizes: the bonnet shape showed unmistakable Rolls-Royce influence. From fast tourers they progressed in 1931 to a real sports car in the shape of the low-chassis '$4\frac{1}{2}$' with massive underslung frame and plated external exhausts. After an over-publicised accident at Brooklands, people suspected the handling, but the Invicta could certainly go, to the tune of 95 m.p.h. The Meadows unit's reliability was attested by its use in light tanks, and at any period other than a world depression, a price of under £1,000 would have been a sure attraction.

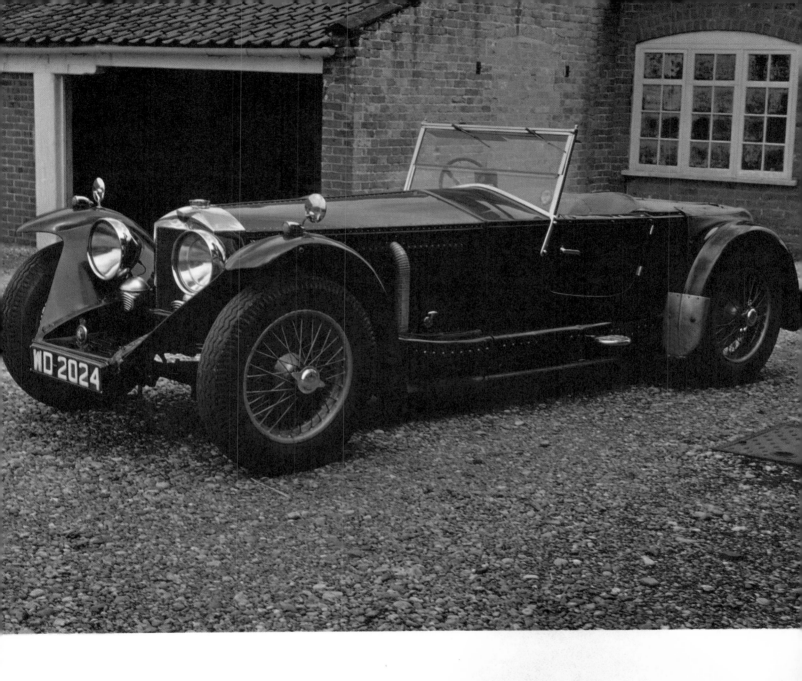

INVICTA 4½-LITRE S-TYPE, 1931

Georges Roesch's 1927 '14-45' Talbot was laid down as a medium-priced family tourer capable of evolution without recourse to expensive re-tooling. By 1930 it had grown up into the 2.3-litre '90', which was fast, quiet, and possessed of almost clockwork reliability on the circuits. 1931 saw something even better, the Fox and Nicholl racing four-seater '105' with 3-litre engine disposing of 140 b.h.p. GO 52, seen here, took third place in the 1931 Irish Grand Prix, won its class in the 'Double-Twelve' at Brooklands, and managed a lap at 112.9 m.p.h. in the Brooklands '500'—all this with a straightforward pushrod six-cylinder engine, too. A standard tourer could be bought for £835 in 1932.

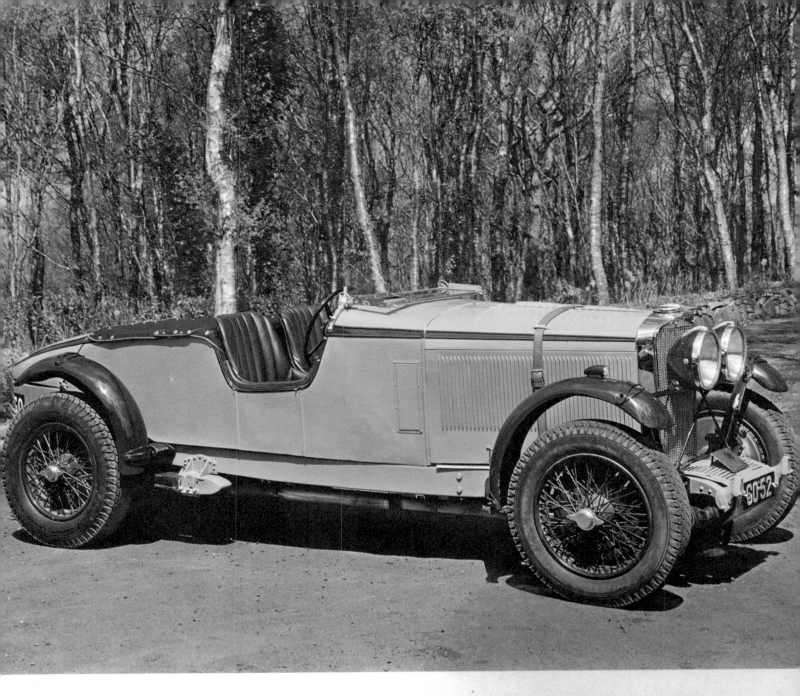

TALBOT '105', 1931

In the years of *formule libre*, Alfa-Romeo, both the works team and later under Scuderia Ferrari direction, assumed the mantle of Bugatti in the Grand Prix world. Only the advent of the state-aided German teams in 1934 ended the make's reign, and even then a *monoposto* in the right hands could still score, as witness Nuvolari's dramatic victory in the 1935 German G.P. One of the best-looking of all racing cars, this was a twin-cam straight-eight with blower drive taken from the centre of the crankshaft, and final drive by twin propeller shafts running vee-wise from the gearbox to points outboard on the rigid rear axle. Output was 180 b.h.p., and speeds of the order of 140 m.p.h. were attained. An ex-Ferrari car, this one was owned by the French independent 'Raph' before coming to England.

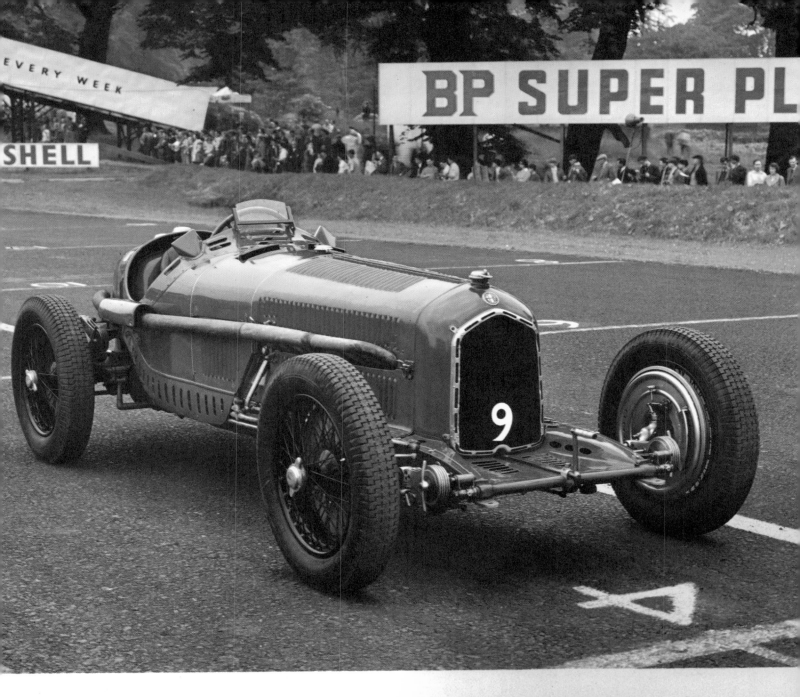

ALFA-ROMEO 2.9-LITRE GRAND PRIX, 1932/4

For all the talk of the 'degenerate 30s', the era produced some superbly elegant coachwork, if one did not mind shallow screens, long bonnets, and blind rear quarters. Many of the loveliest examples found their way on to Louis Delage's 4-litre D.8 chassis introduced in 1929, which two years later had been developed into the shortened and lowered D.8, a 100 m.p.h. car which proved its status by averaging 117.8 m.p.h. for three hours at Montlhéry. Specification included a pushrod straight-eight engine with valve springs divorced from their valves, a high-lift camshaft, high-ratio back axle, and four-speed gearbox. I.f.s. was as yet used only on smaller and cheaper Delages, incidentally. This body was the work of Gurney Nutting.

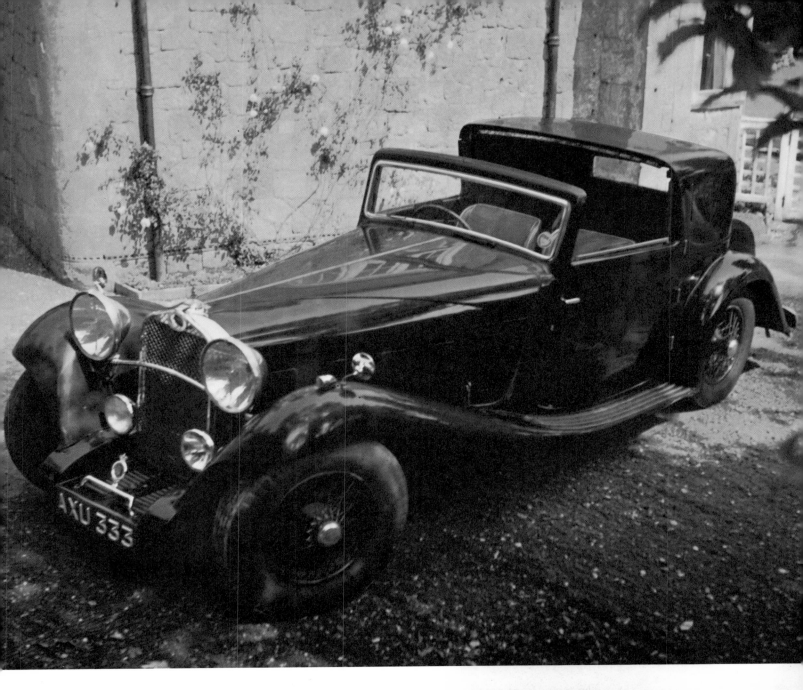

DELAGE D.8 SS 100, 1933

Descendant of the 'Ghost', the 7.7-litre 'Phantom II' with o.h.v. engine replaced the 'Phantom I' in 1929. Cylinders were still cast in threes, but a new and stiff frame, unit construction of engine and gearbox, and semi-elliptic springs were now incorporated, while the servo brakes were of superlative quality. A short-chassis version was produced by Ivan Evernden for Sir Henry Royce's personal use on the Continent, and a demand for replicas resulted in the 'Continental', a Rolls-Royce for the connoisseur who wanted to motor fast without loss of the virtues traditionally associated with Derby. Nearly 100 m.p.h. was possible, and this sedanca coupé (exceptionally by Barker instead of by Gurney Nutting) represents British *haute couture* at its zenith.

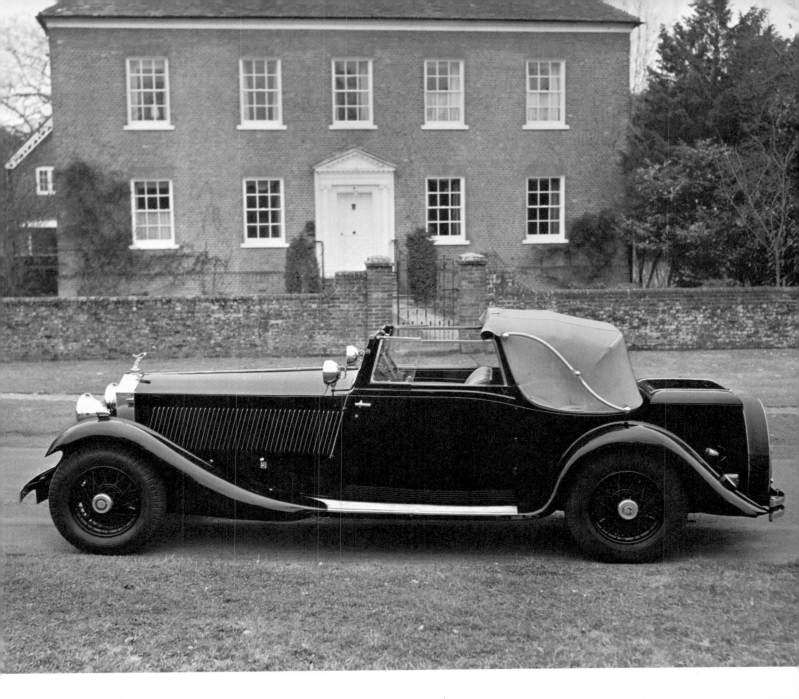

ROLLS-ROYCE PHANTOM II 'CONTINENTAL' (SHORT CHASSIS), 1933

The Aston Martin formula has always been the same—enthusiast-sponsored sports cars of the highest quality. A $1\frac{1}{2}$-litre engine was standard wear up to 1936, the A. C. Bertelli-designed overhead-camshaft model with bodywork by his brother Enrico appearing in 1927. Output rose from 50 to 63 b.h.p. with the advent of the dry-sump engine in 1928, and by 1934 the Mark II was giving 70 b.h.p., and had acquired a unit gearbox. It was heavy for a '1500' at 23 cwt, and also expensive, but its top speed of 85 m.p.h. was more than adequate, and the handling was unquestionably thoroughbred. Apart from the Zeiss lamps, this example is in original condition.

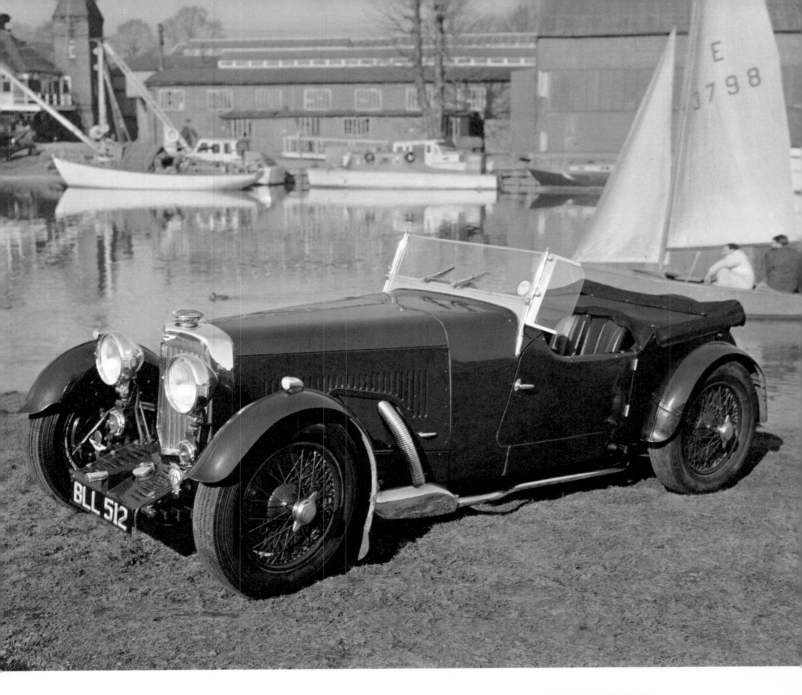

ASTON MARTIN MARK II, 1934

A favourite of the hagiographers—and of the debunkers, too—the Duesenberg was a remarkable automobile. To achieve 116 m.p.h., even with 265 b.h.p. under the bonnet, from a touring car with a wheelbase of nearly 12 feet and a weight of 45 cwt was quite something in 1929, and the superbly-made 32-valve twin o.h.c. 6.9-litre straight-eight engine was understandably not as quiet as some of its rivals. Also, the 'J' cost around $16,000 with reasonably simple bodywork, and was thus for the favoured few. The addition of a centrifugal blower in 1932 resulted in the 320 b.h.p. 'SJ', seen here with 'convertible torpedo victoria' body by Rollston. Production ceased in 1937, after about 470 of both types had been made.

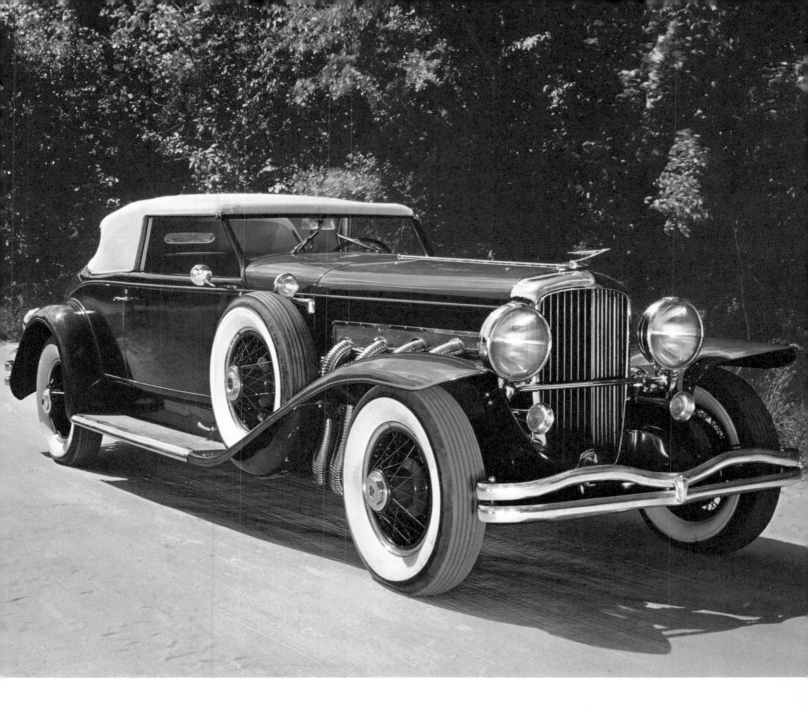

DUESENBERG 'SJ', 1934

Archie Frazer-Nash and H. R. Godfrey of G.N. fame set out to build a car that would be fast and safe to drive, easy to tune and maintain, and not too expensive for the competition-minded amateur, and the Aldington brothers, who took over manufacture in 1928, carried on the tradition. All Frazer Nashes up to 1939 had multiple-chain final drive transmitted to a solid back axle by means of sliding dog-clutches—the best way of assuring the ideal ratio for a given need. Various makes of engine were used—by Meadows, Blackburne and Anzani—this 1934 Tourist Trophy team car has the o.h.c. four-cylinder 'Gough' unit made by the factory themselves.

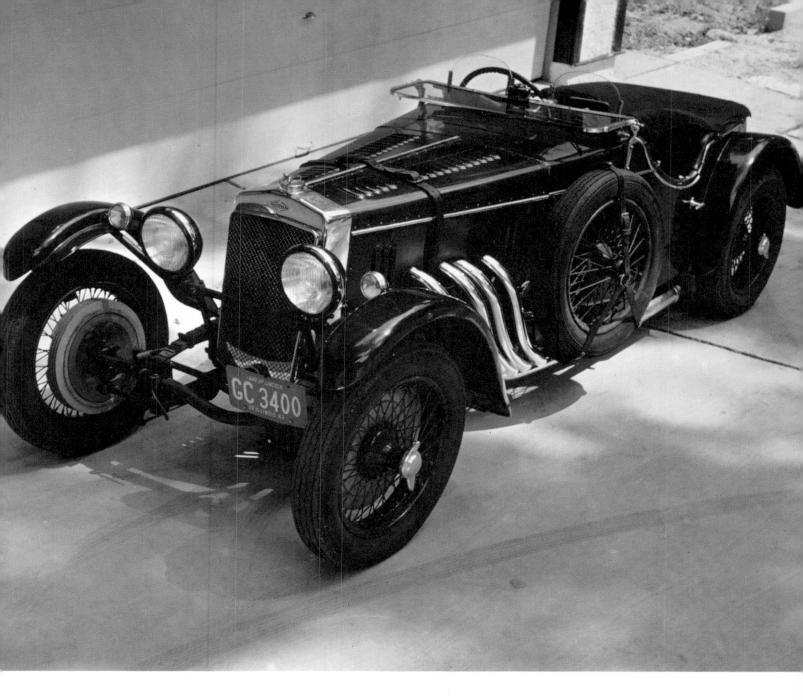

FRAZER NASH TOURIST TROPHY, 1934

Percy Riley's Nine of 1926 was a 'natural' for development, with its twin camshafts carried high in the crankcase and hemispherical head, and by 1930 90 b.h.p. had been extracted from racing engines—rather too much for a two-bearing crank. There had been a companion six-cylinder since 1929, and by 1934 this had evolved into the beautifully-proportioned 'M.P.H.', obviously inspired by the Zagato Alfa-Romeo. A 6-85 m.p.h. range on top gear was justly claimed, output from 1,633 c.c. was 70 b.h.p., and buyers had the choice of close-ratio 'crash' or Wilson preselector gearboxes. At £550 it helped to justify Riley's contemporary slogan: 'The Most Successful Car in the World.'

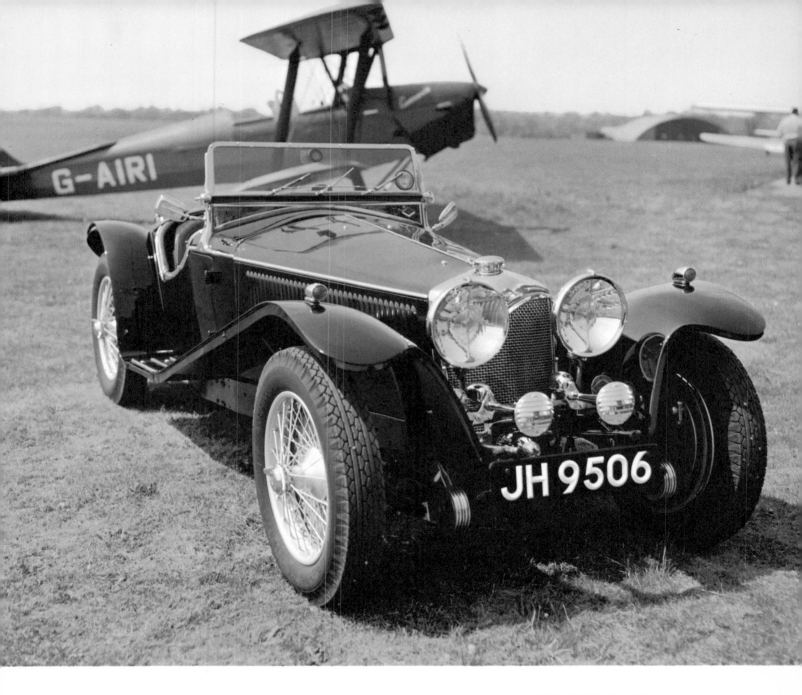

RILEY 'M.P.H.', 1934

E. L. Cord's policy as owner of Auburn from 1924 was to give the public the $5,000 look and above-par performance for low prices, and in 1932 he even managed to offer a V-12 for under $1,000. The blown 'eight', last of the line, was certainly handsome, if a trifle flashy, and its 4½-litre s.v. Lycoming engine pushed out 150 b.h.p. with the aid of a centrifugal supercharger. The result was a certified 100 m.p.h. (commemorated by a plaque on the dash of every speedster), and even if the car did not like corners as well as it should, it was something different in an age of uniformity. An interesting feature was a two-speed back axle giving six forward ratios, and hydraulic brakes were standard.

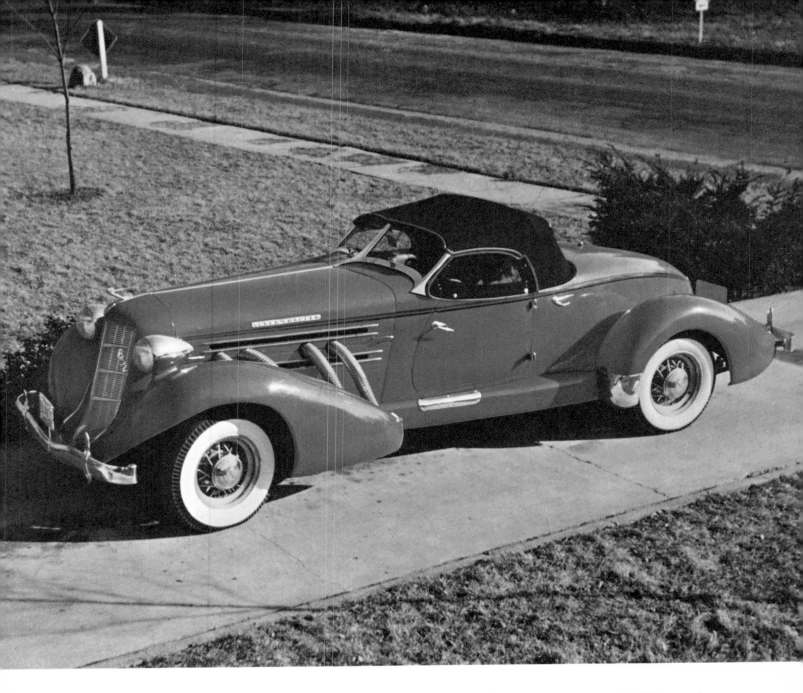

AUBURN 852 SUPERCHARGED SPEEDSTER, 1936

Britain was a notable absentee from Grand Prix racing in the 1930s, but made up for this with her successes in the *voiturette* class. The car responsible was the E.R.A., built by Peter Berthon in association with Raymond Mays, and powered by a development of the twin-high-camshaft six-cylinder Riley engine in 1,100 c.c., 1½-litre and 2-litre sizes. Reid Railton's chassis showed Maserati inspiration, and acceleration was helped by the use of a preselector gearbox. Among the drivers associated with the *marque* were Earl Howe, Dick Seaman, 'B. Bira', Arthur Dobson and Raymond Mays. Here is Bira's 'Remus', still active in historic racing to this day.

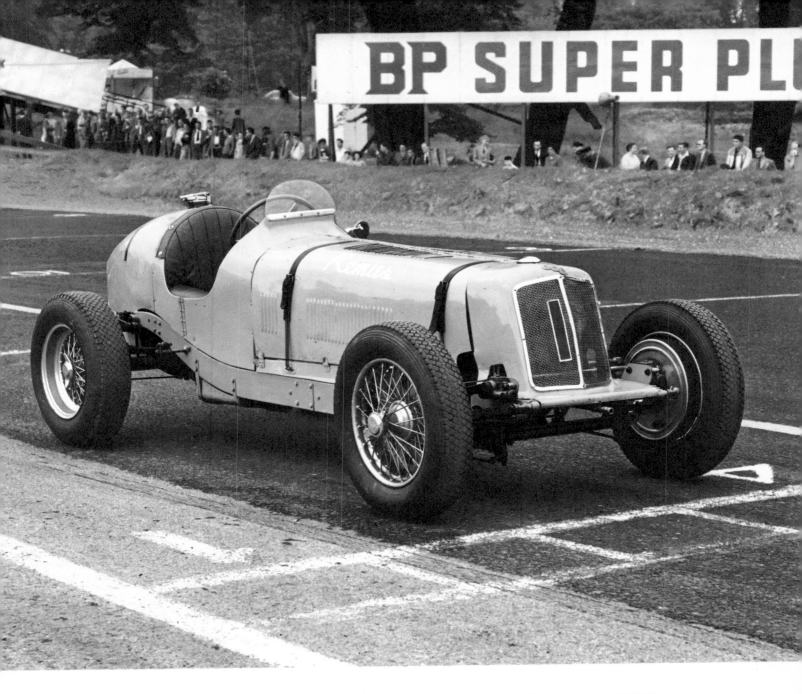

E.R.A. 1½-LITRE, 1936

New York's Museum of Modern Art considered this the outstanding modern car design in 1952, 17 years after E. L. Cord unveiled the second front-wheel drive model to bear his name. Power came from a 4.7-litre Lycoming Vee-8 engine, and other features included constant-velocity universal joints, independent front suspension, and an electrically-selected four-speed gearbox. But it was the combination of wrap-round grille and retractable headlamps that singled the Cord out for the layman. It would go—102 m.p.h. in supercharged 170 b.h.p. form on a 2.75:1 overdrive top gear. Prolonged teething troubles, a shortage of capital, and the American phobia of the unconventional killed it after less than 3,000 had been made, and an attempt to launch a scaled-down derivative with proprietary engine in 1963 was equally abortive.

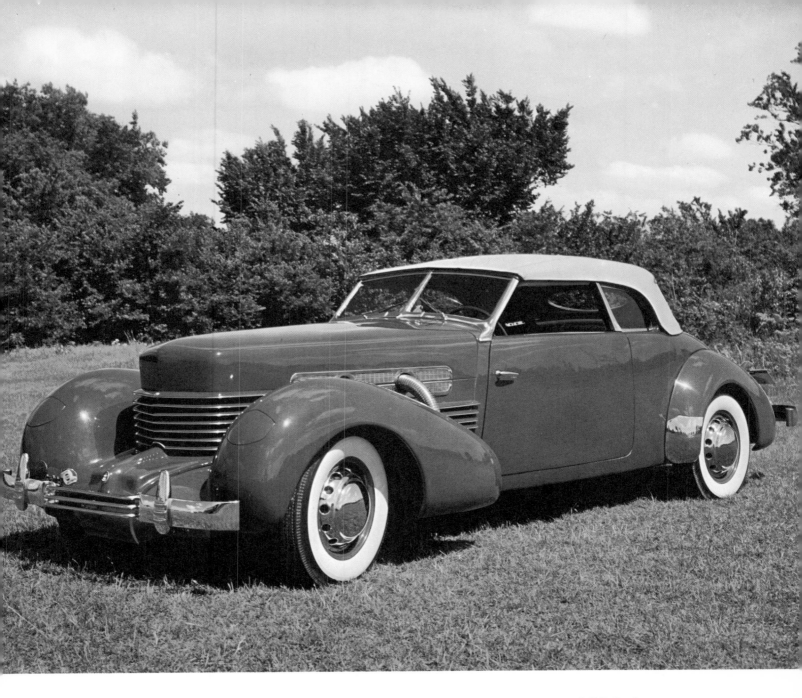

CORD 812, 1937

The solidly-built, traditionally British fast tourer made up in durability and fine workmanship what it lacked in *panache,* and the $4\frac{1}{2}$-litre Lagonda with its long-stroke six-cylinder pushrod Meadows engine is an excellent example of this theme. Introduced for 1934 at only £795, it was the only model to survive a receivership a year later, and under W. O. Bentley's supervision it was refined, and given a stiffer crankshaft and Weslake-designed cylinder head, as well as softer springing and Girling brakes. An entirely new chassis with independent torsion-bar suspension and hydraulic brakes appeared for 1938, this being used also for the complex and advanced V-12. One of the two 'spare wheel covers' on this elegant factory-bodied drophead coupé houses the tools.

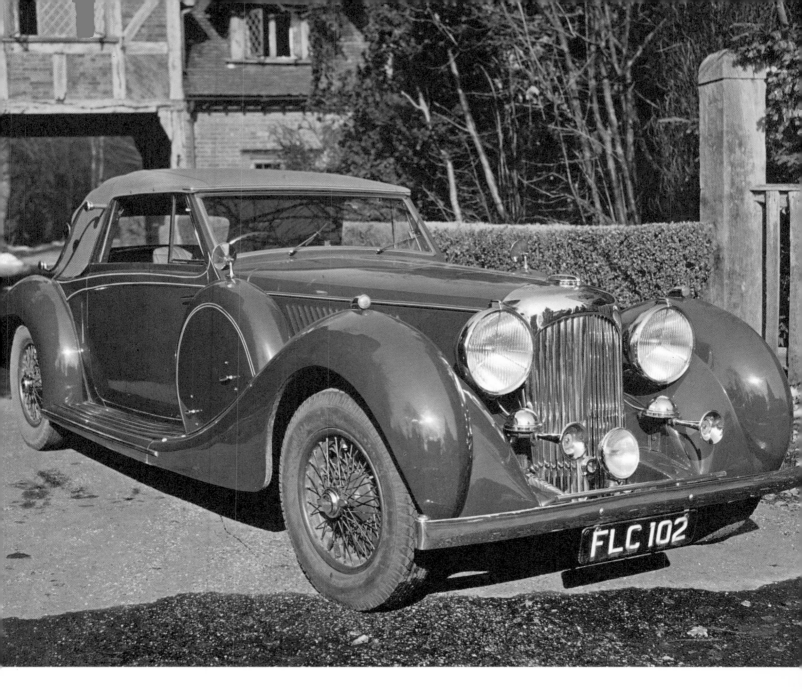

LAGONDA LG.6, 1938

Many unkind sobriquets were applied to the early Jaguar, but where else could one have bought an 100 m.p.h. sports car with a simple and reliable 125 b.h.p. pushrod engine and synchromesh gearbox for £445 in 1938? Outcome of the S.S.I, a specially-adapted six-cylinder Standard chassis with lowslung coupé bodywork, the S.S.100 appeared with 2½-litre engine at the 1935 London Show, and quickly proved itself, not only in domestic rallies, but also in the Alpine Trial. The 3½-litre was new for 1938, and would reach 60 m.p.h. in 10.4 seconds. Admittedly it was tricky in the wet, and prone to gyrate on tight circuits like the Crystal Palace, but it went as well as it looked, and surviving specimens of the 300-odd built fetch astronomical prices in the United States.

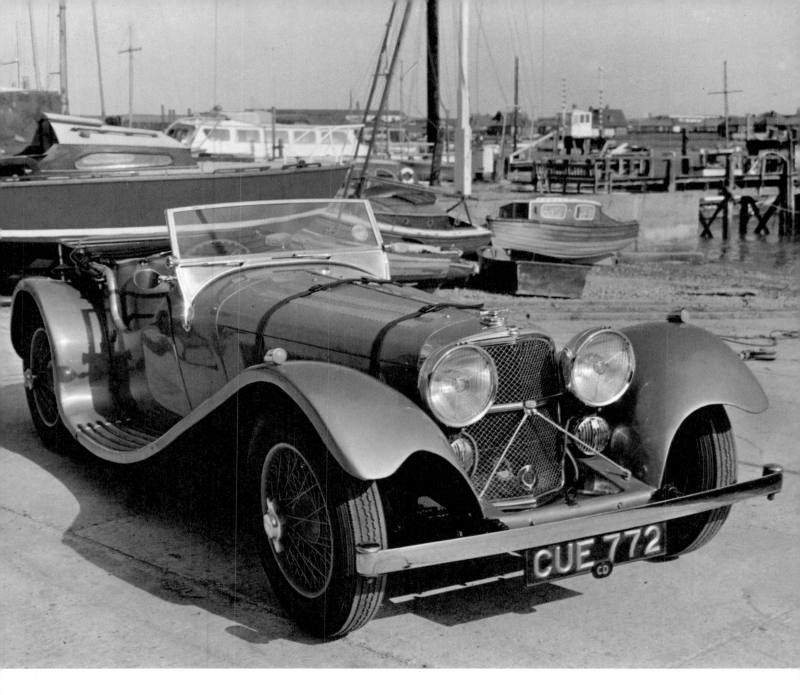

S.S. JAGUAR 3½-LITRE '100', 1938

By 1932 the famous '12-50' was nearing the end of its run, and Alvis were turning increasingly to six-cylinder engines, based on their 'Silver Eagle' of 1928. As always, the cars were on the heavy side, but they were beautifully made and well-braked, the 2½-litre 'Speed 20' being revised for 1934 with a massive chassis, transverse independent front suspension, and all-synchromesh gearbox. Bigger cars followed, a 3½-litre in 1936, and the 4.3-litre a year later. In short-chassis tourer form the car weighed 35 cwt, but this did not prevent it from recording 100.84 m.p.h. on test, as well as accelerating from rest to 60 m.p.h. in 11.9 seconds. And this combination of performance and comfort could be bought for less than £1,000.

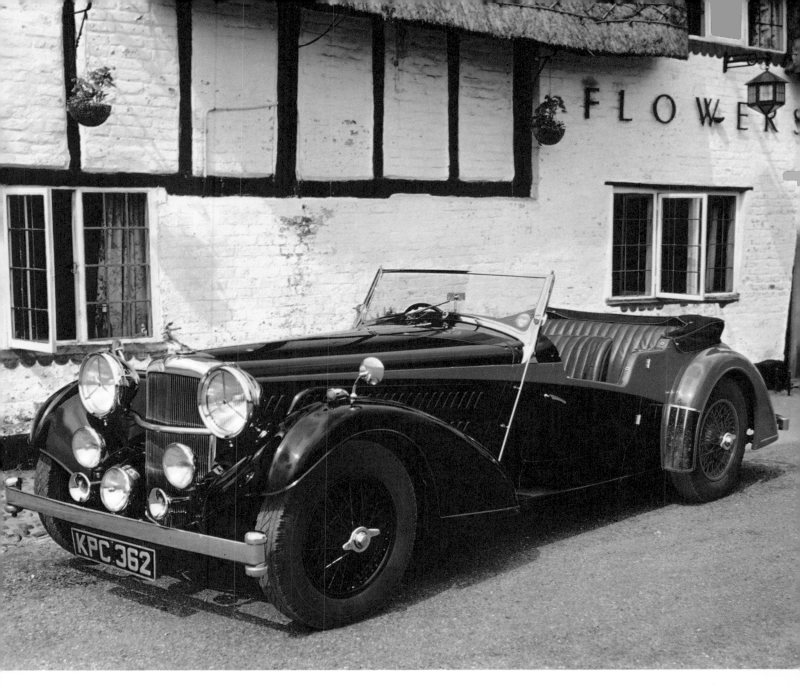

ALVIS 4.3-LITRE, 1939

The 'big banger' ($4\frac{1}{2}$-litres unblown) had its merits: and Antoine Lago reaped his reward under the first post-war G.P. formula, when his Talbots managed to win races on clockwork reliability and a modest thirst. At its peak, the $1\frac{1}{2}$-litre Alfetta got through a gallon of petrol every two miles, whereas the Lagos averaged 9 m.p.g. and could dispense with refuelling stops. The six-cylinder engine, with inclined valves and pushrods from two high camshafts, disposed of a mere 240 b.h.p., but temperance won it the 1950 French and Belgian Grands Prix. The chassis was orthodox with independent suspension at the front only, and a Wilson preselector gearbox was used. Here Louis Chiron is seen in action in the 1948 British Grand Prix.

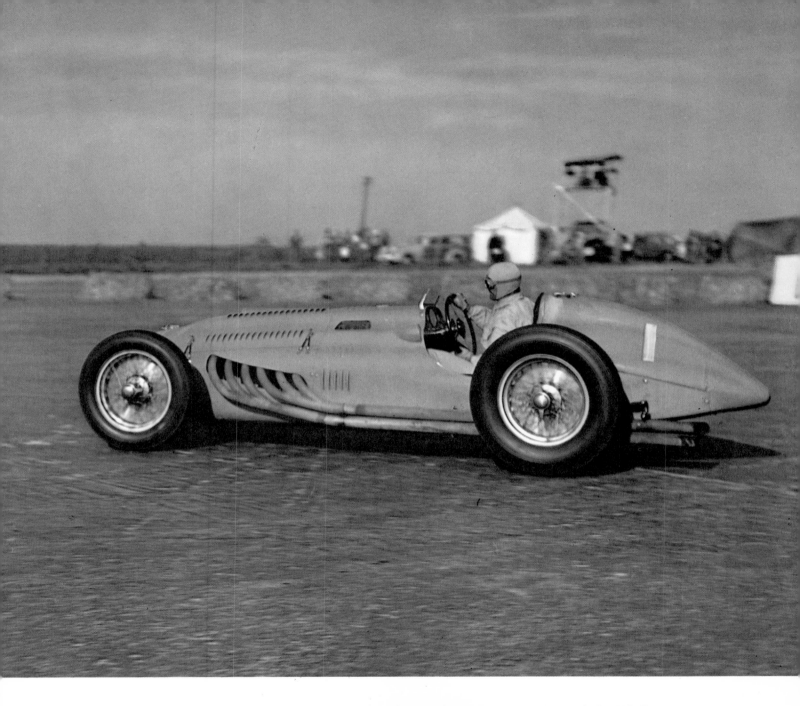

LAGO-TALBOT 4½-LITRE, 1948

Born 1938, retired 1951, and still modern to the end of its days, the $1\frac{1}{2}$-litre Alfetta started life as a *voiturette* and ended up as a Formula I car. Output rose from 195 b.h.p. to nearly 400, and in its last season speeds of around 190 m.p.h. were being achieved. A twin o.h.c. straight-eight in the Alfa tradition, it had a tubular frame, independent suspension all round by trailing arms at the front and swing axles at the rear, and a four-speed gearbox behind the driver. A De Dion axle was adopted in 1951. Here is Fangio at Silverstone for the 1950 British G.P., in a season when the *marque* recorded 11 starts and 11 first places.

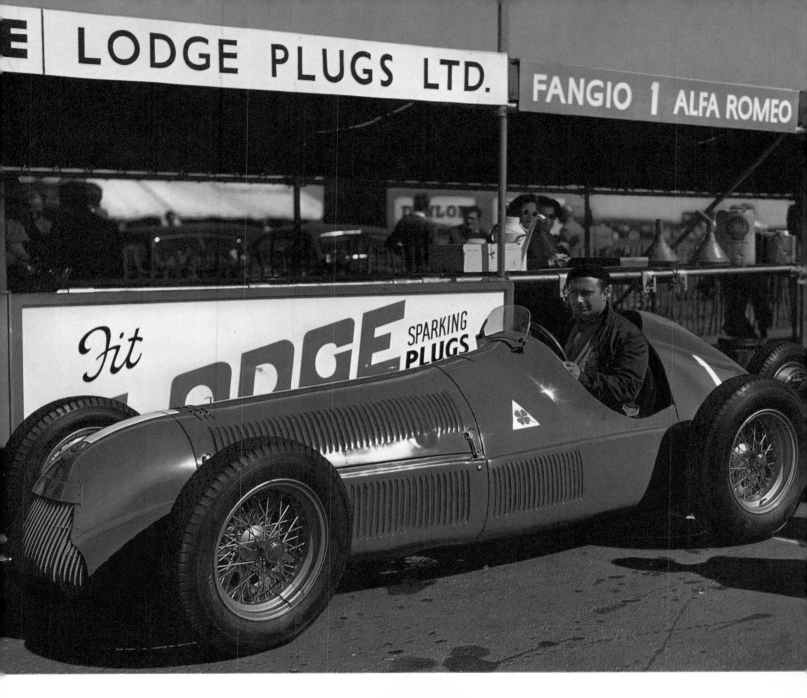

ALFA-ROMEO 158/159, 1950

This might be termed a 'box-office' Formula I racer, since by the end of 1951 Ferrari's unblown 4½'s had made life too hot for the opposition. Alfa-Romeo had withdrawn, and the V-16 B.R.M. was still unready, so promoters hitched their wagons to the thriving 2-litre Formula II. Ferrari's F.II car was a development machine for the coming 2½-litre formula, and a very good one, too. The engine was an oversquare twin-cam. 'four', giving 160 b.h.p., the gearbox lived astern, and there were immense brakes and a De Dion axle. It was beaten only once in 1952, and then in a non-Championship race. Of the *grandes épreuves*, Ascari won six, and Taruffi the remaining one. Here Farina is seen in action during the British G.P. at Silverstone.

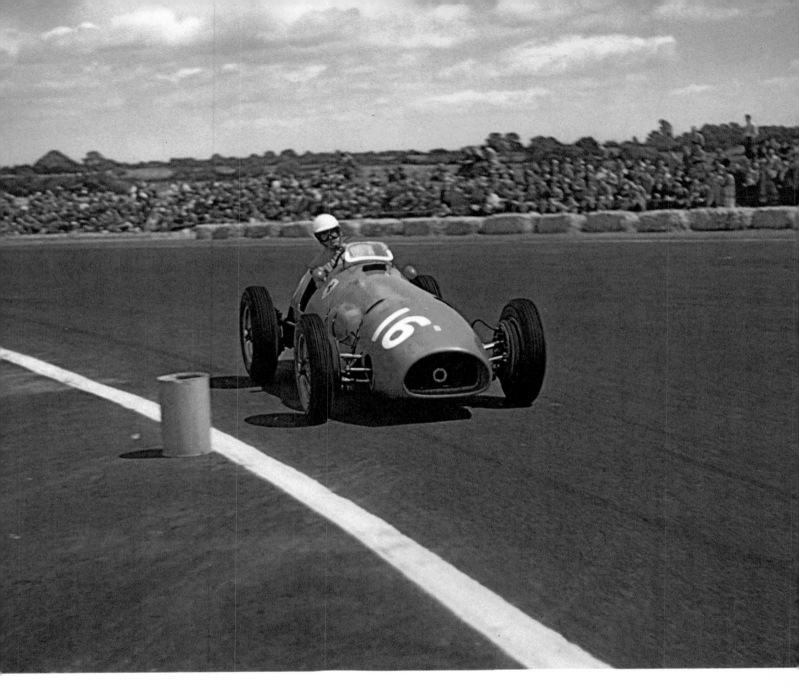

FERRARI 2-LITRE, 1952

Briggs Cunningham devoted himself for several years to brave but unavailing endeavours to win Le Mans for America, starting in 1950 with a bizarre aerodynamic Cadillac, and then turning to Chrysler- and Offenhauser-powered cars of his own make. 1953 was his best year, with 3rd, 7th, and 10th places on Cunninghams using 235 b.h.p. Chrysler Vee-8 engines and live axles in place of the De Dion type used on the earlier C-1 and C-2. Both manual and automatic gearboxes were tried. In the background is a 'cooking' version—the C-3 model with Vignale coupé body made in very small numbers at $10,000 a unit. Cunningham's ill-luck held, however, and it was left to Ford in the following decade to triumph over Ferrari on the Sarthe Circuit.

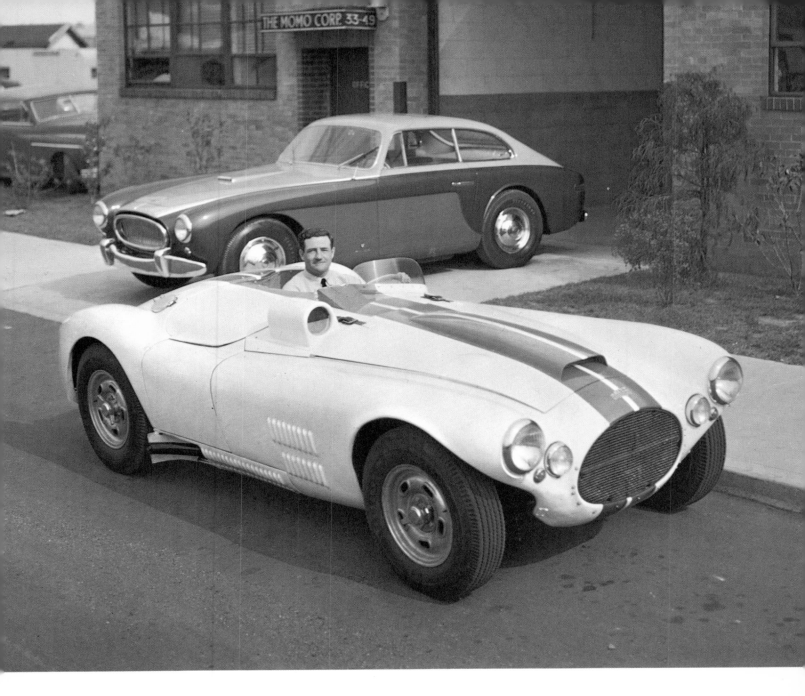

CUNNINGHAM C-4R, 1953

Amedée Gordini started off with Simca-based lightweights equivalent to modern Formula Juniors, ideal for smaller and twistier circuits. On his own by 1952, he pursued the same theme with a 2.1-litre twin o.h.c. 'six' mounted in a tubular frame with all-round torsion-bar suspension. These wore the blue of France proudly, and at Rheims that year Jean Behra defeated the might of Ferrari. Alas, there were never enough funds behind *le sorcier,* and an attempt to 'stretch' the original engine to $2\frac{1}{2}$ litres for Formula I never paid off, even though Gordini used the same unit in his sports cars. By 1957 he was working on tuned versions of Renault's 'Dauphine'. Here Da Silva Ramos is seen with the $2\frac{1}{2}$-litre Gordini at Silverstone.

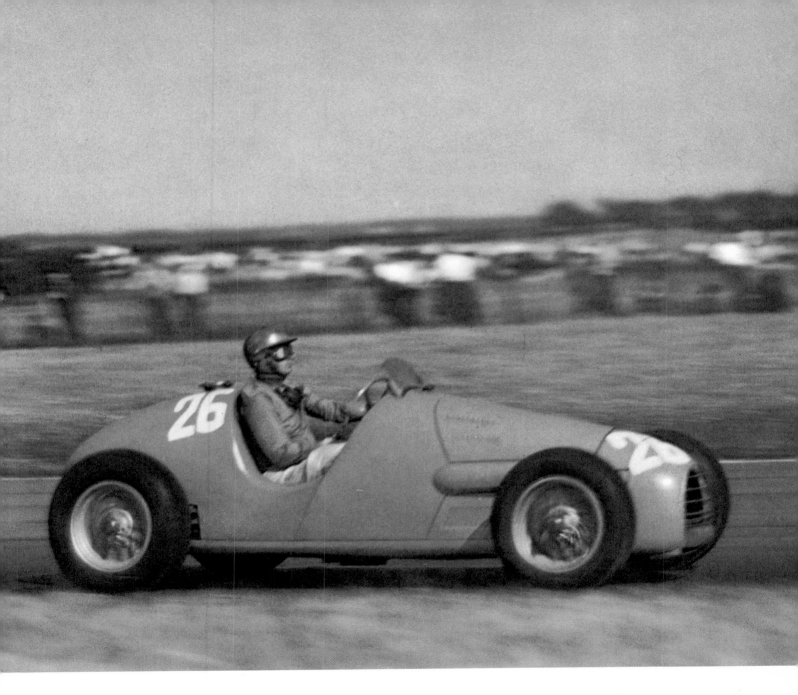

GORDINI, 1954

Conceived as part of the factory's plan to run 'the fastest scheduled service over the Sarthe circuit', the D-type finished second at Le Mans in 1954, first in 1955 and 1956, and its glorious zenith came in 1957 with Jaguars in five of the first six places. The Frère/Rousselle car, seen here, was fourth. Heart of the matter was the celebrated twin-cam. six-cylinder engine found in all production models since 1951, allied to monocoque construction, the Dunlop disc brakes pioneered on the C-type, but not as yet independent rear suspension, as on the E-types of today. This was first seen on Briggs Cunningham's experimental 3-litre Le Mans machine in 1960.

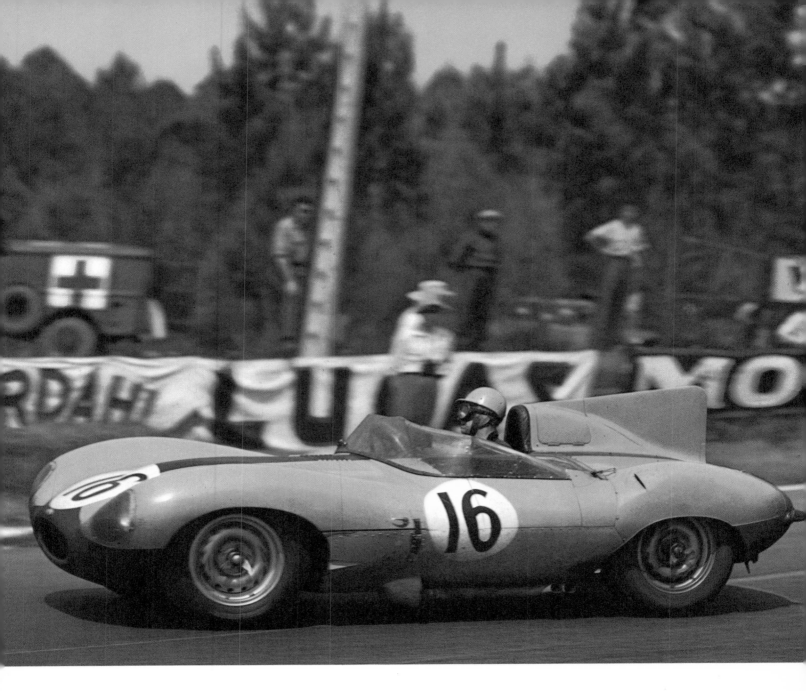

JAGUAR D-TYPE, 1954

The 2½-litre Formula of 1954 saw the dawn of a new era—the end of supercharging. Like Ferrari, Maserati had been gaining experience during the Formula II interregnum, and their solution was a twin-overhead-camshaft 240 b.h.p. 'six' mounted in a light chassis of narrow tubes. The four-speed gearbox was in unit with the De Dion rear axle, though five forward speeds were found on 1955 cars, and fuel injection was also tried. Maserati started off well by winning the Argentine G.P. in January 1954, and continued to prosper while Mercedes-Benz's W196 was still unready. 1957 was the 250F's best year, when it won Fangio the World Championship. Here Stirling Moss is seen on his way to victory at Monaco in 1956.

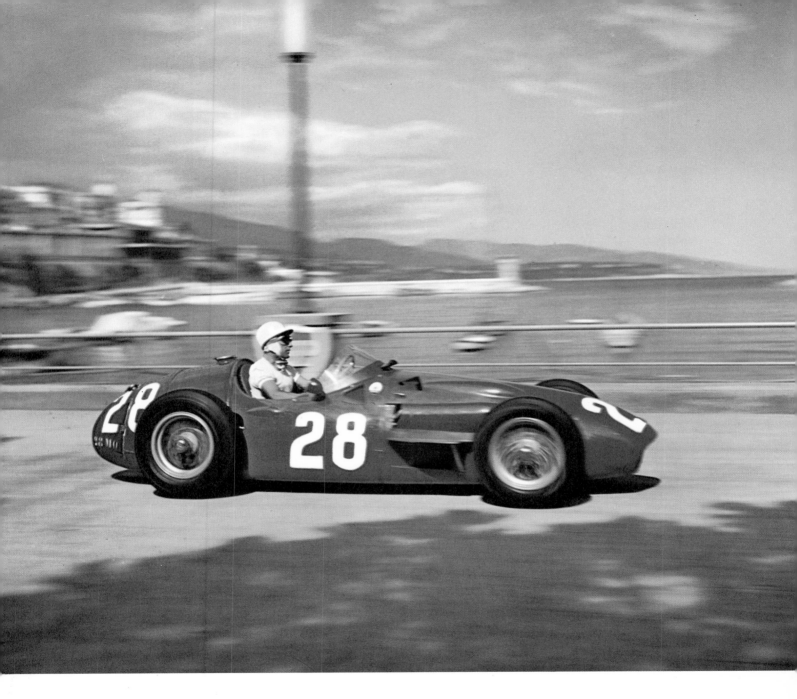

MASERATI 250F, 1954/6

First of the post-war sports cars from Untertürkheim, the 300SL coupé with gull-wing doors hinged along the roof had a good season as a prototype in 1952, victories including the Prix de Berne, Le Mans and the sports category of the Carrera Panamericana. The first of over 3,000 production models appeared in 1954: specification included a multi-tubular space-frame and a fuel-injected six-cylinder single o.h.c. 3-litre engine developing a creditable 215 b.h.p. If its 130 m.p.h. was not as fast as was expected, and the handling required care, it possessed real 'kick-in-the-back' acceleration. Later models had more conventional roadster bodywork and disc brakes.

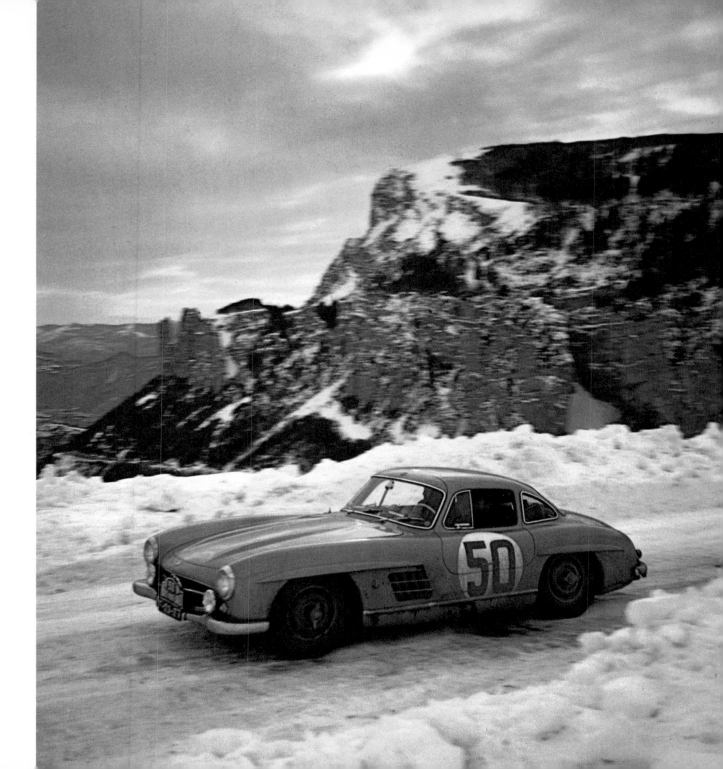

Having revived their sports cars, Daimler-Benz staged another magnificent comeback in Formula I—and they did it thoroughly with a twin-overhead-camshaft straight-eight engine, lying almost on its side in a frame of bicycle-sized tubes with inboard brakes and swing-axle rear suspension.. Desmodromic valve gear, opening and closing each valve positively, was adopted. Both fully-enveloping and 'open' bodies were used, according to circuit, and one of the latter is seen with Stirling Moss in the 1955 British G.P., which he won. The reckoning in a two-year programe—four firsts in 1954, five in 1955, and two World Championships for Fangio.

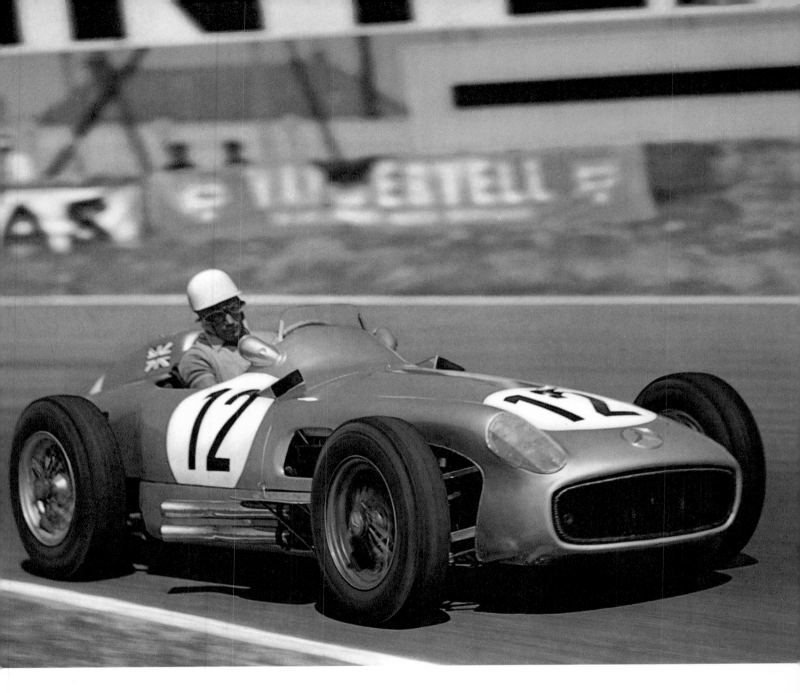

MERCEDES-BENZ W196, 1954/5

Two firsts for Tony Brooks: the first Formula I victory for a British driver at the wheel of an all-British car, and the first Grand Prix won on disc brakes—a fitting reward for a small firm nurtured on the 2-litre Formula II. In F.I form the Connaught had a twin o.h.c. 250 b.h.p. four-cylinder Alta engine, mounted in a twin-tube frame, with suspension by wishbones at the front and a De Dion rear axle. The heavy but quick-changing preselector gearbox was used. The inevitable problems of under-capitalisation had sent Connaught to the wall by 1957, but the B-type had earned its niche in history. Here one of the cars is seen at Syracuse a year after its great moment, in 1956.

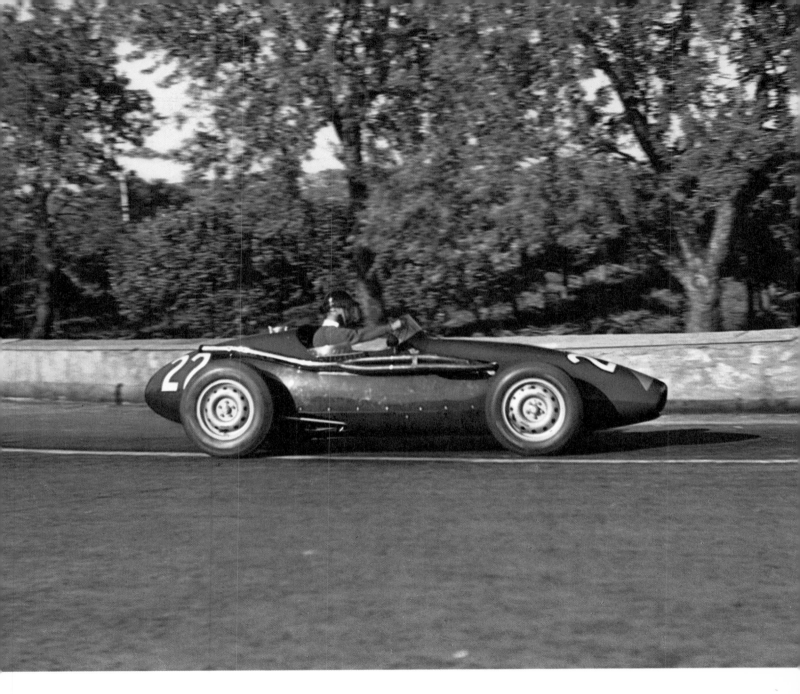

CONNAUGHT 'SYRACUSE', 1955

Maybe mass-production has taken its toll of Alfa-Romeo since the days of the 1750GS, but you still have the beautifully-built twin o.h.c. engine —now a five-bearing 1,290 c.c. 'four' with 80 b.h.p. on tap, and smooth if not quiet up to 6,300 r.p.m. The rear suspension (by live axle, coil springs and radius arms) really allowed this one to be thrown about, and the writer remembers having this demonstrated to him in Manhattan, of all places. In 1956 some of this gilt was tarnished by a less-than-prepossessing steering-column gear change, and in those days one couldn't get an Alfa with right-hand drive, either.

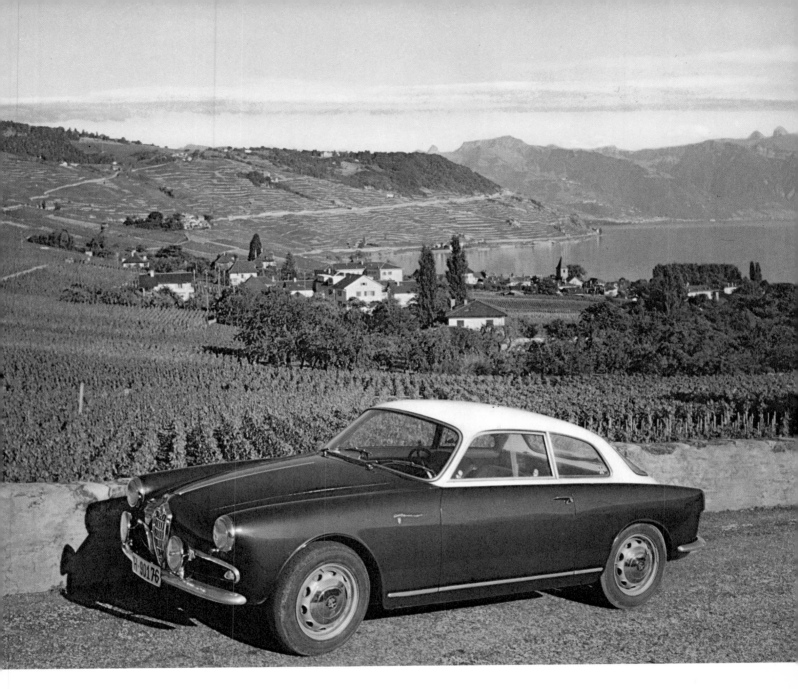

ALFA-ROMEO 'GIULIETTA', 1956

This was not so much a sports car as the translation of a European theme into the American idiom. Ford themselves called it a 'personal car', and the original ones were two-seaters with no pretensions to being homes on wheels. The 'Thunderbird' started out with a modest 130 b.h.p. V-8 engine, but by 1956 had grown into a 5.1-litre with 225 b.h.p., weighing over 30 cwt and offering 115 m.p.h.; options available included electric window lifts and an automatic transmission, with floor-mounted selector. Handling and brakes were typically Detroit, which is why the breed was seldom seen in competition, and after 1957 it became merely another large and gimmicky motor car for four people. But the original and unadorned 'T' Bird well deserves its place here on aesthetic merit.

FORD 'THUNDERBIRD', 1956

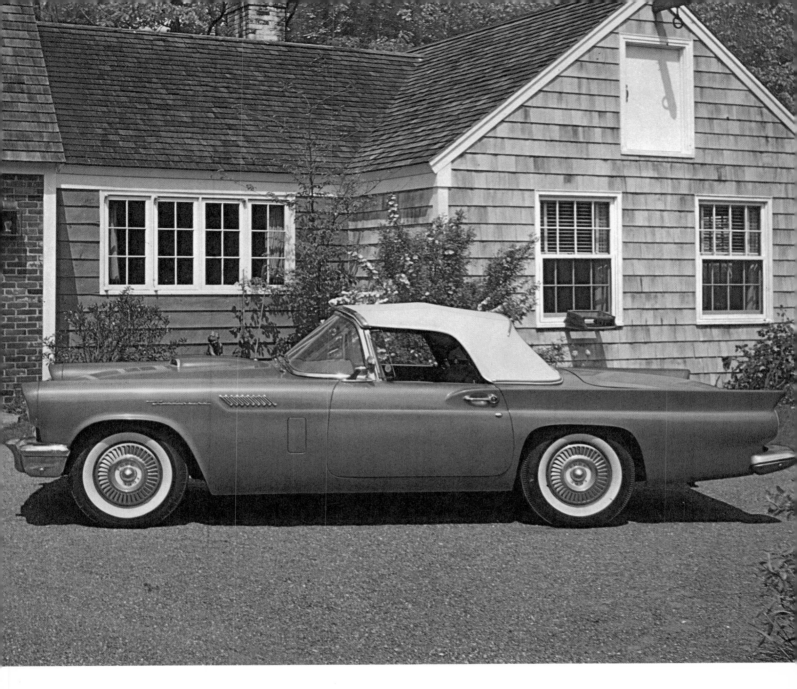

FORD 'THUNDERBIRD', 1956

Hardly recognisable now as a descendant of Ferdinand Porsche's Volkswagen except in basic layout, the rear-engined, air-cooled car from Stuttgart-Zuffenhausen remains an acquired taste, and in its early days had a tail-wagging habit which defeated many an expert. However, safety and stability improved vastly down the years, and on a modern Porsche it is surprising how one finds oneself cornering 15 m.p.h. faster than with a conventional configuration. Speed, economy, ease of control and superlative finish are found here in a combination not easily matched. Here the Maglioli/Barth 718RS sports-racer is seen at Le Mans in 1957: the four o.h.c. $1\frac{1}{2}$-litre engine developed over 140 b.h.p., and lived ahead of the transmission, there was an oil cooler in the nose, and two small stabiliser fins at the rear.

PORSCHE 718RS, 1957

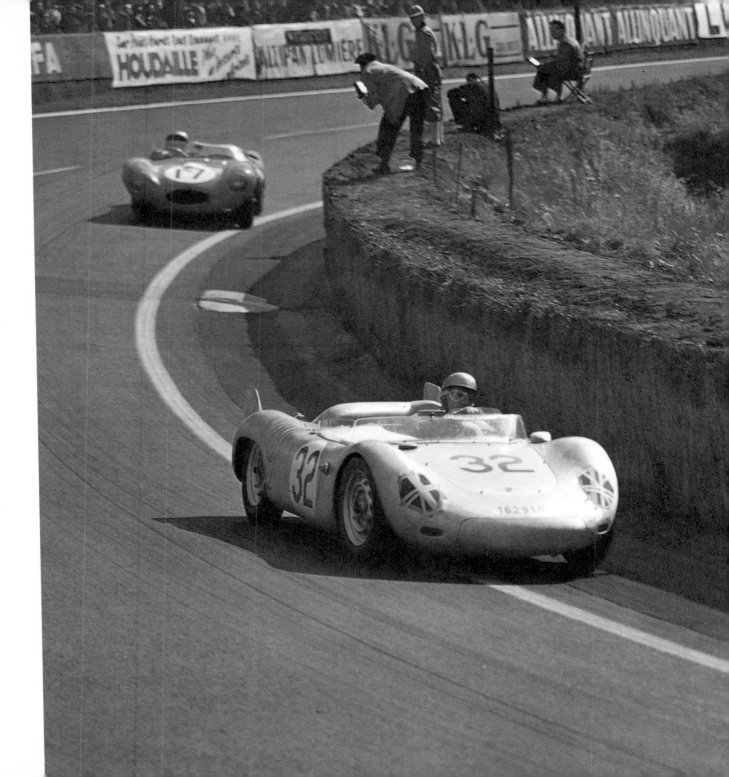

Ferrari already had a V-6 engine for Formula II, and when aviation petrol became compulsory under Formula I rules this 60-degree unit was enlarged to 2,417 c.c., and ran in both single o.h.c. 250 b.h.p. and twin o.h.c. 280 b.h.p. forms. Another influence this year was the reduction of the minimum race distance from 500 to 300 kilometres: allied to a more economical fuel, this meant less tankage, and corresponding reductions in chassis weight and tyre size. It also led the way to the low-profile rear-engined machinery, but let this Ferrari, seen with Mike Hawthorn at Monaco in his Championship year, take its place as the last of the traditional brigade.

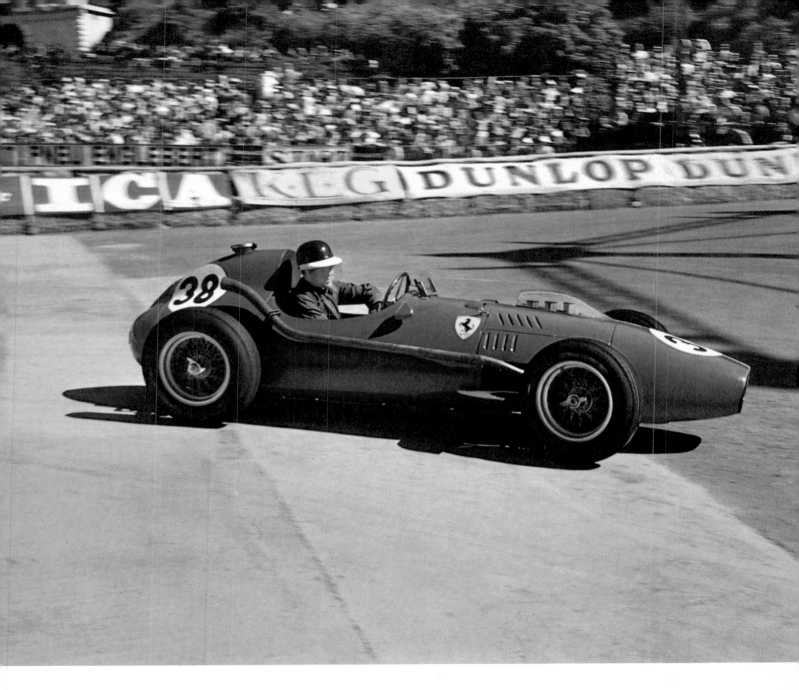

FERRARI DINO 246, 1958

If the smaller constructors have to rely on proprietary engines, they can maintain their customer-loyalty by going in for lightness and superior road-holding. Few can have achieved more than Colin Chapman, whose rise from a part-time builder of trials specials has been meteoric. His first closed car, the 'Elite', used a moulded-fibreglass monocoque structure, and power came from a 75 b.h.p., 1,216 c.c. single o.h.c. Coventry-Climax engine. A dry weight of $10\frac{3}{4}$ cwt helped to give a top speed of 110 m.p.h., and in adhesion, steering and retardation (by Girling discs) the machine had few rivals. It was, however, rather too noisy to rate as a British Porsche. Here the Clark/Whitmore car is seen at Le Mans in 1959.

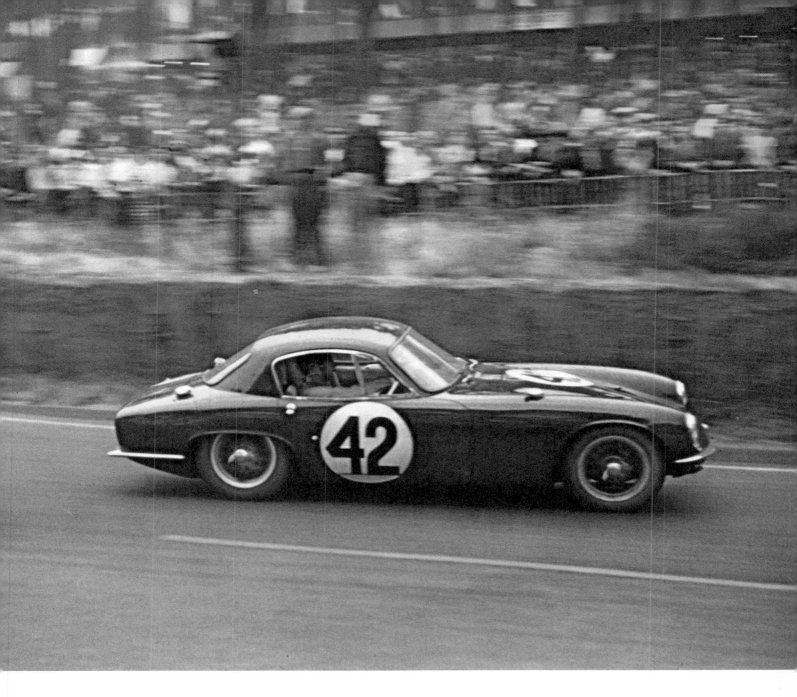

LOTUS 'ELITE', 1958

Seen here on a Tulip Rally is one of the hardly perennials of the sports-car scene. Way back in 1910 H. F. S. Morgan built a three-wheeled runabout with independent, sliding-pillar front suspension, and the four-wheeler line which originated in 1936 has followed in the same tradition. Morgans still have separate wings, flat screens, exposed spare wheels, old-type two-piece bonnets, plywood floors, and spartan weather protection. Comfort, in fact, isn't even a secondary consideration, but despite limited production (nine a week) the Morgan remains inexpensive (£881 with the 2,138 c.c. Triumph TR unit). Most of them are exported. Apart from bought-out components, the cars are largely built by hand.

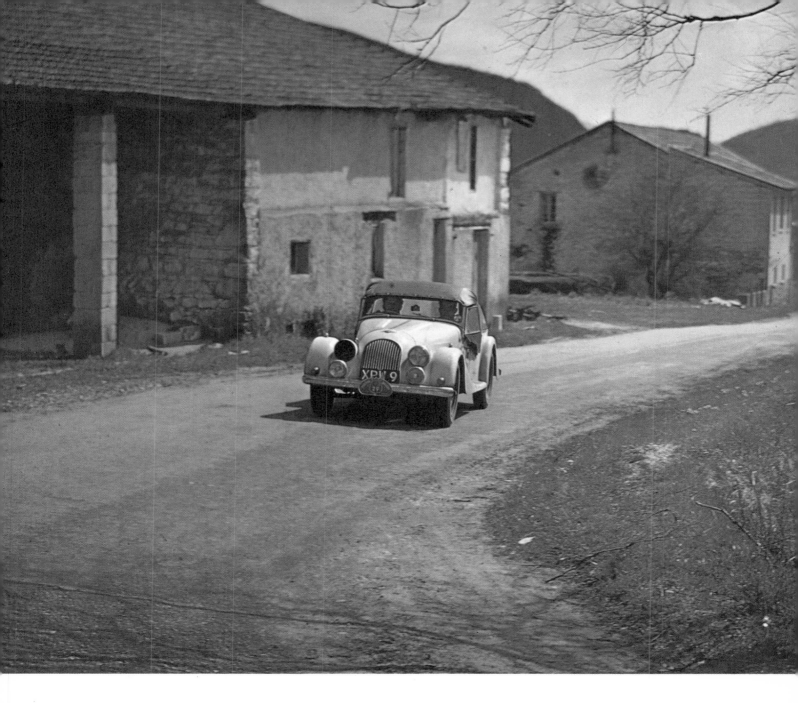

MORGAN 'PLUS-FOUR', 1958

'Slicks', sponsors' slogans, and two-speed gearboxes were standard wear for the Indianapolis Speedway, with its four banked left-handers, and so was the 4.2-litre unblown Offenhauser engine. The Novi was the exception that proved the rule, using an immensely powerful blown 2.8-litre four o.h.c. Vee-8 engine (700 b.h.p. at 8,200 r.p.m. were claimed towards the end of its career). It was also persistently unlucky, struggling on from 1947 to 1964, with no better reward than a third place in 1948. A f.w.d. car until 1955, it is here seen with Paul Russo and a conventional Kurtis chassis three years later. The Novi engine was even tried in a four-wheel-drive Ferguson chassis—but without success.

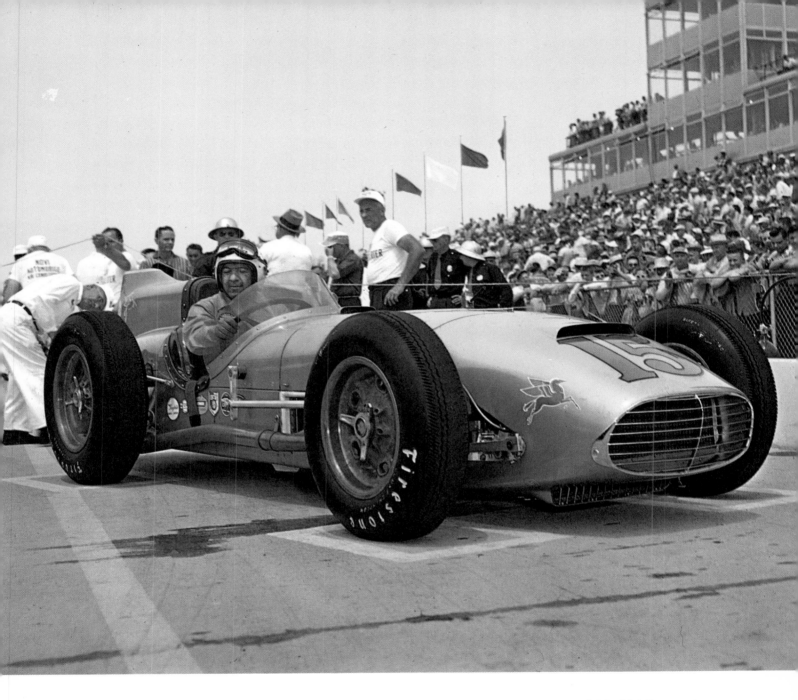

NOVI AUTOMOTIVE AIR CONDITIONING SPECIAL, 1958

Unkind critics sought to trace Ferrari ancestry in Tony Vandervell's Vanwalls—after all, his entry into racing came with the 'Thinwall' Ferrari specials—but the car's wishbone front suspension and De Dion axle were pretty general practice, anway. Unique to the breed were the Norton-inspired twin o.h.c. four-cylinder engine and the Goodyear disc brakes. By 1956 the recipe had been modified to include fuel injection, a new multi-tubular frame designed by Colin Chapman, and bodywork by Frank Costin with long tapering nose. Triumph came in 1957 with three major victories, and 1958 saw six wins and Britain's first lead in the Constructors' Championship.

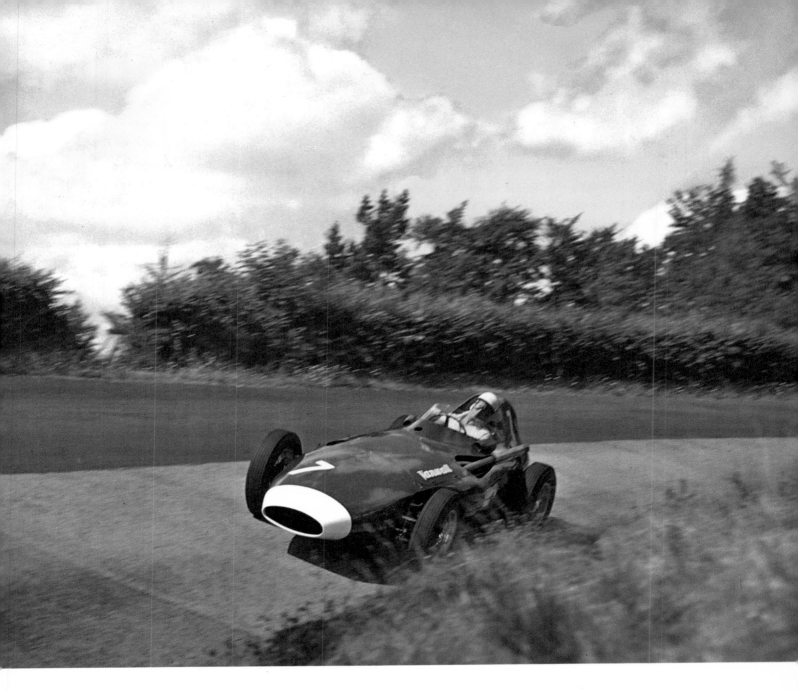

VANWALL, 1958

The only British *marque* to carry off the Sports Car Constructors'
Championship. The DBR.1's wins included the Nürburgring 1,000
kilometre Race (for the third year in succession), and first and second
places at Le Mans. Here is Maurice Trintignant on his way to fourth
place in the Tourist Trophy. International regulations put these cars
out of the running after the golden year of 1959, but the work of John
Wyer, the company's technical director, had certainly paid off, and
today's DB.6 reflects the lessons learned on the circuits. Power came
from a 3-litre twin o.h.c. six-cylinder engine developing some 260 b.h.p.,
and mounted in a space-frame built up of small-diameter chrome
molybdenum tubes. Torsion-bar suspension was used all round, and
there was a De Dion rear axle.

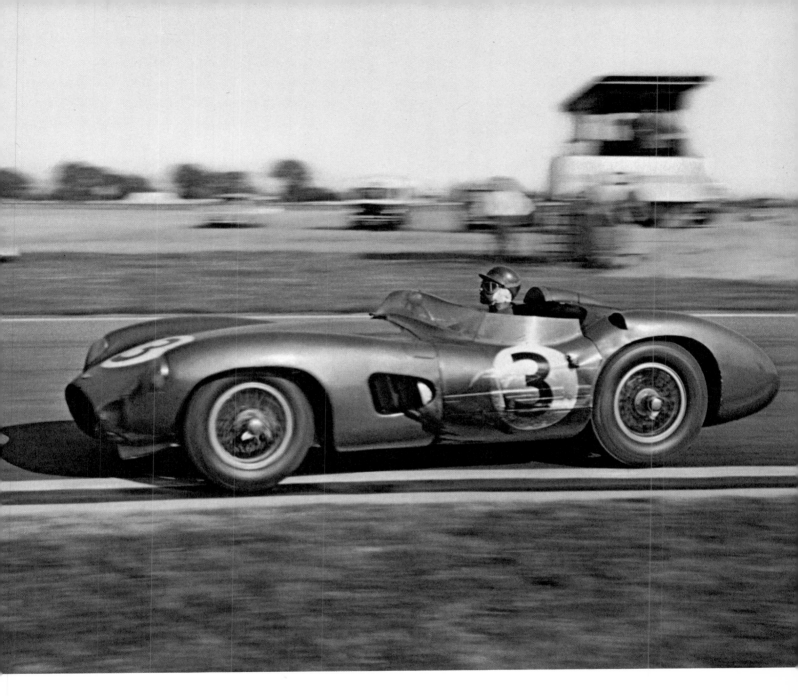

ASTON MARTIN DBR.1, 1959

The 'angry pussy-cats' of the old Formula III, with their FIAT 500 suspension and rear-mounted motor-cycle engines, were designed as poor man's racers. With the advent of the Avgas ruling and the 300-kilometre Grand Prix in 1958, the Cooper layout moved up to Formula I, now that acceleration and manoeuvrability counted more than sheer speed. With a 'stretched' Formula II Coventry-Climax engine developing about 200 b.h.p., it won the Argentine and Monaco races in that year, but by 1959 a full 2½-litre unit was available, and Cooper enjoyed a season in which they *failed* to win only three events—one of them the French G.P., in which Jack Brabham is here seen. Having specialised in this scheme of things far longer than their rivals, Cooper started with an advantage which they held for some time.

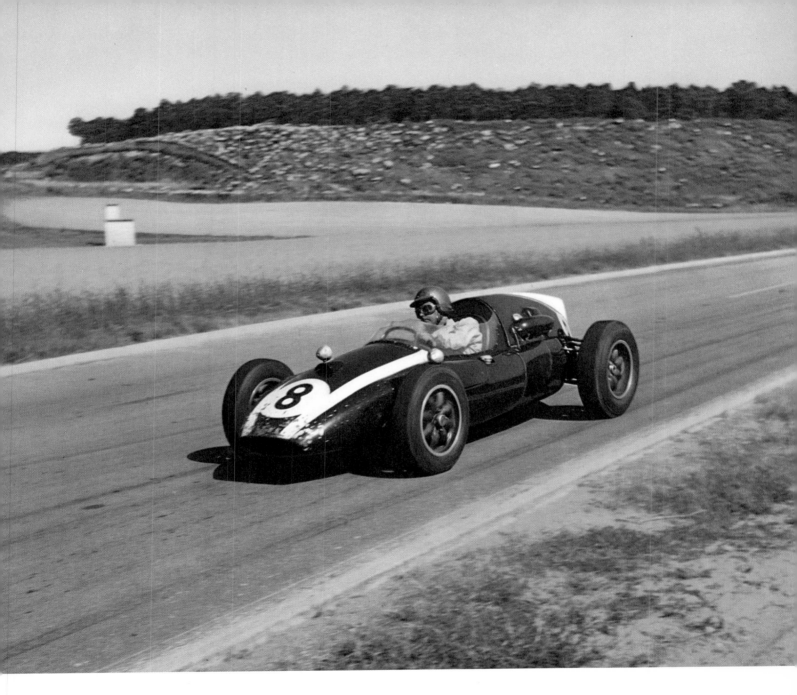

COOPER, 1959

Not only in competition has Ettore Bugatti's pre-war mantle fallen upon Enzo Ferrari's shoulders. Alongside a complex range of sports and racing machinery there have also been some superb overhead-camshaft V-12 Gran Turismo cars, for discriminating clients with £6,000-plus (or, say, $10,500) to spend. Typical of the firm's 1959 offerings is this Scaglietti-bodied roadster with 2,953 c.c. twin-cam. engine, coil-spring independent suspension, and 280 b.h.p. under the bonnet, combining speeds of the order of 140 m.p.h. with a docility that is somehow un-expected. In 1967 the 'standard' model (if such a term may be applied to Ferraris) was the '275' with 3.3-litre 300 b.h.p. engine, five-speed gearbox, and all-round disc brakes.

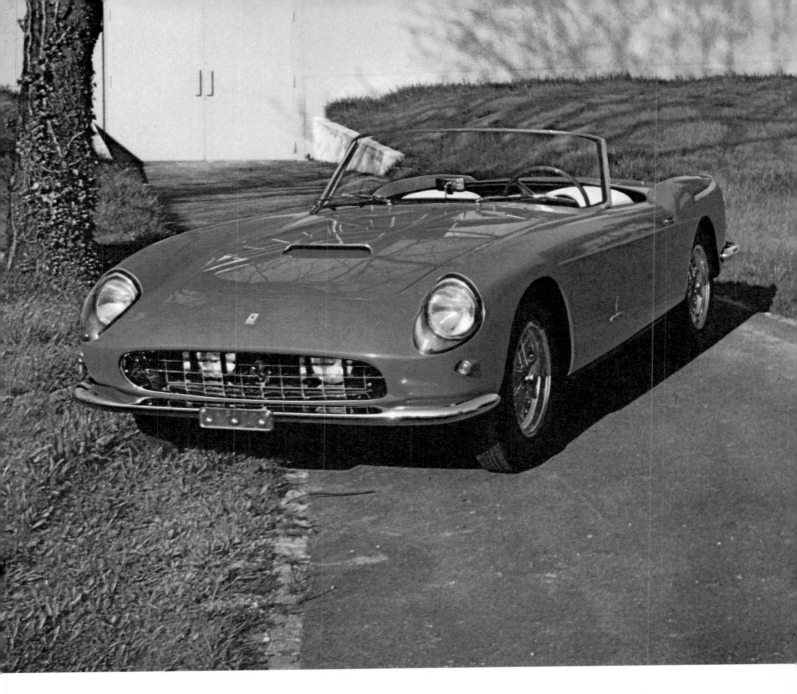

FERRARI-250GT CALIFORNIA, 1959

Brutal, if you like; simple, almost to the point of ugliness: but none the less a first-rate compromise between utility, performance, creature comfort and durability. The engine was the tough old 2-litre Standard 'Vanguard'; the chassis derived from the little 'Mayflower' saloon of 1950. Front disc brakes were fitted as early as 1956, and triple overdrive was optional, giving it literally 'a gear for every gradient'. If the handling was not of the easiest always, here was a car in which one could commute to the office on weekdays, and amass silverware at weekends. Over 100 m.p.h. was available, and so was a modest thirst of 25 m.p.g. with reasonable driving.

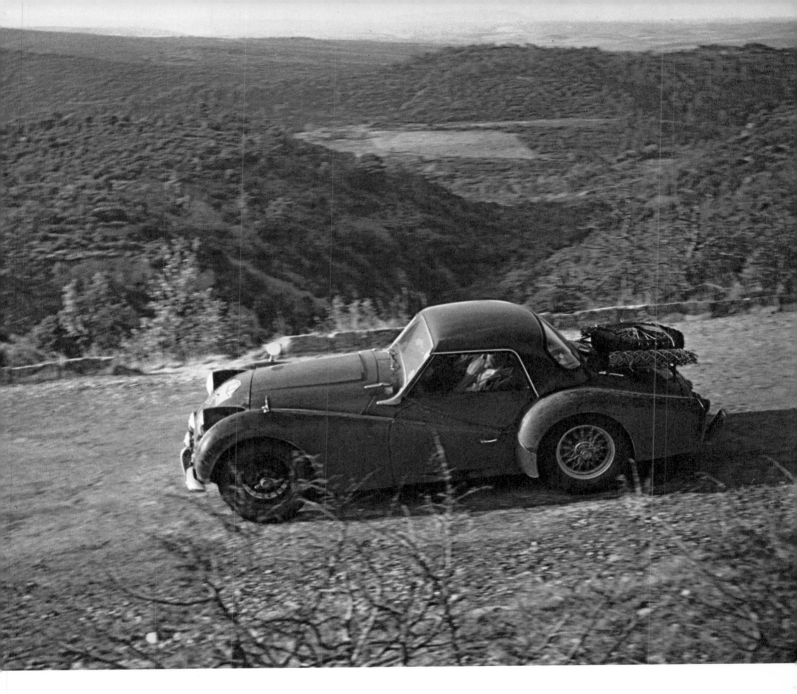

TRIUMPH TR.3, 1959

Almost every cheap family car in Italy is a FIAT; ergo, the best way to create something bespoke and fast is to stir the basic ingredients of the rear-engined 600 model, and add an aerodynamic body by Zagato or Bertone. This is what Carlo Abarth has been doing to good purpose for many years, and here is the proverbial quart in a pint pot, with single- or twin-camshaft head to order. Result is nearer 70 than the 30 b.h.p. of the standard FIAT. The domes in the roof are essential to save the passengers from concussion, as the little car stands only 4ft. 7in. from the ground. A regular class-winner in rallies and races, the Abarth is here seen at Spa.

ABARTH 750 G.T., 1960

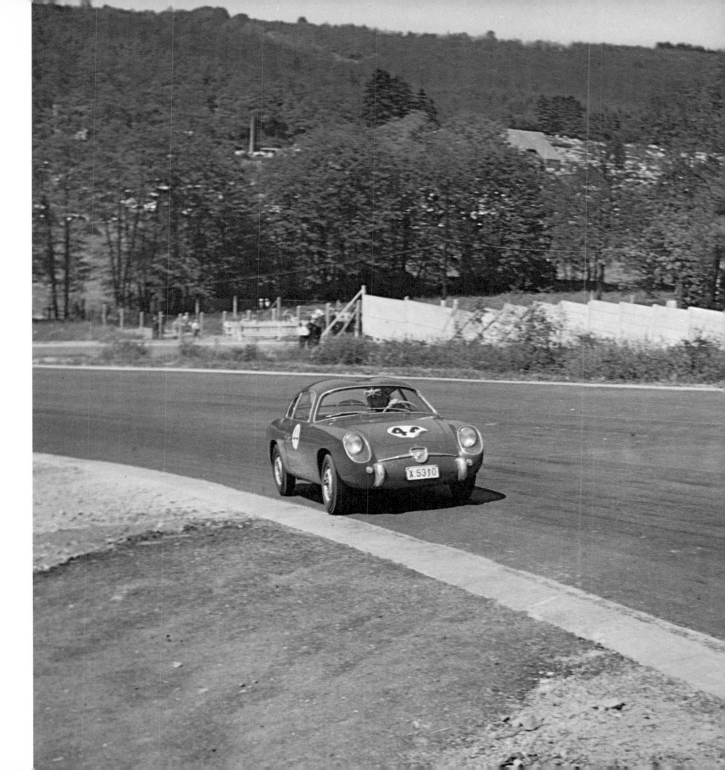

The day of the classic French sports car is over—by 1960 Bugatti, Delahaye and Talbot were all dead. One last stirring of the embers came from the Facel firm, whose big Vee-8 Chrysler-engined coupé was first seen in 1955, and prospered for a few years. Less successful was the 1,600 c.c. 'Facellia' powered by Facel's own twin o.h.c., five-bearing four-cylinder unit, but otherwise conventional in specification. It proved capable of 114 m.p.h.; piston-burning and a heavy oil consumption, however, caused its sponsors to abandon this advanced engine in favour of the reliable push-rod Volvo in 1963. A year later the Facel had gone the way of all the others.

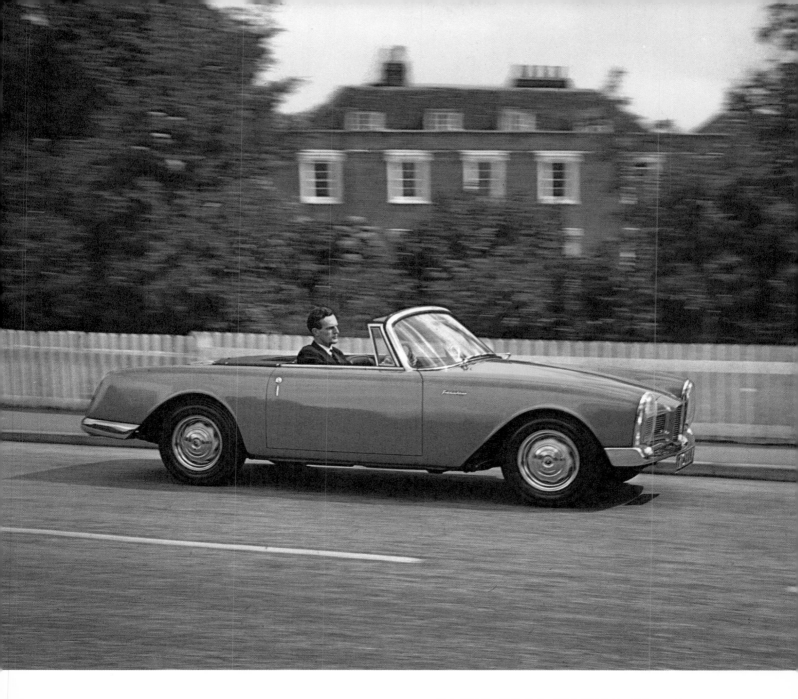

FACEL VEGA 'FACELLIA', 1960

'The triumph of matter over mind' wrote Richard Bensted-Smith of Colin Chapman's first successful G.P. car, a complete *volte face* after a skirmish with a too-ingenious front-engined device using strut-type rear suspension, Vanwall-like body, and five-speed gearbox. The new car had a very light frame, squarish bodywork, transverse-link rear suspension, inboard rear brakes, and the usual 240 b.h.p. Coventry-Climax engine—but at the rear, as on the Cooper. Stirling Moss won at Monaco that year on Rob Walker's car, and a Lotus also won the United States Grand Prix. Despite the lack of a suitable engine for the first $1\frac{1}{2}$-litre Formula events in 1961, Stirling Moss's virtuosity beat the all-conquering Ferraris on two occasions.

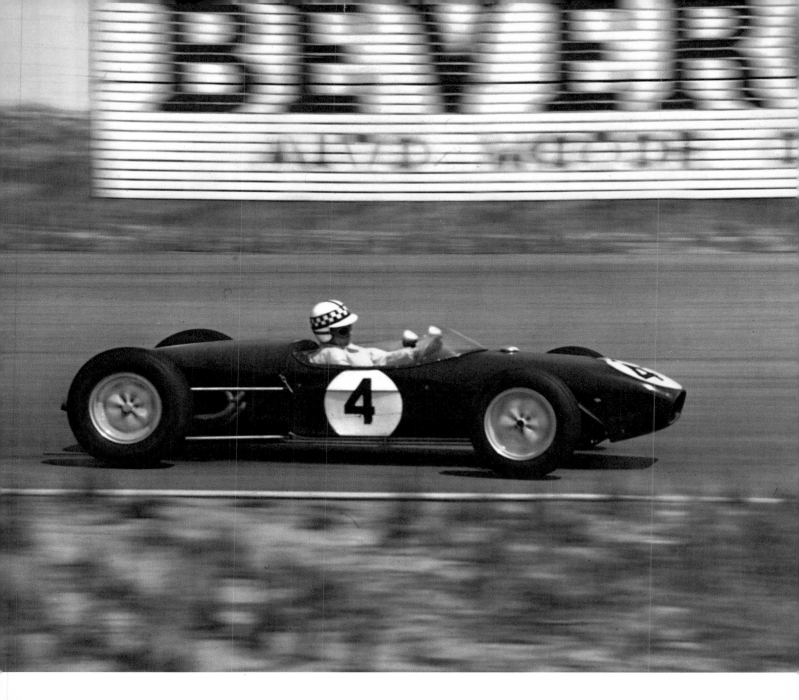

LOTUS XVIII, 1960

Once the rear-engined trend had been established, it would have been surprising had Porsche, the great exponents of this layout, elected to abstain. A four-o.h.c. $1\frac{1}{2}$-litre flat-four four-cylinder Formula II car was entered at Monaco in 1959 for von Trips to drive; this derivative of the RSK sports car had a six-speed gearbox. Here is Graham Hill's 1960 car at Solitude, where the team followed a V-6 Ferrari home. The firm's incursion into Formula I in 1961 and 1962 was not unlike that of some of their British rivals—the chassis was right, but of their engines, the old flat-four was past its peak, while the flat-eight that replaced it was disappointing. Porsche's withdrawal from Grand Prix racing has, however, been followed by success in other fields.

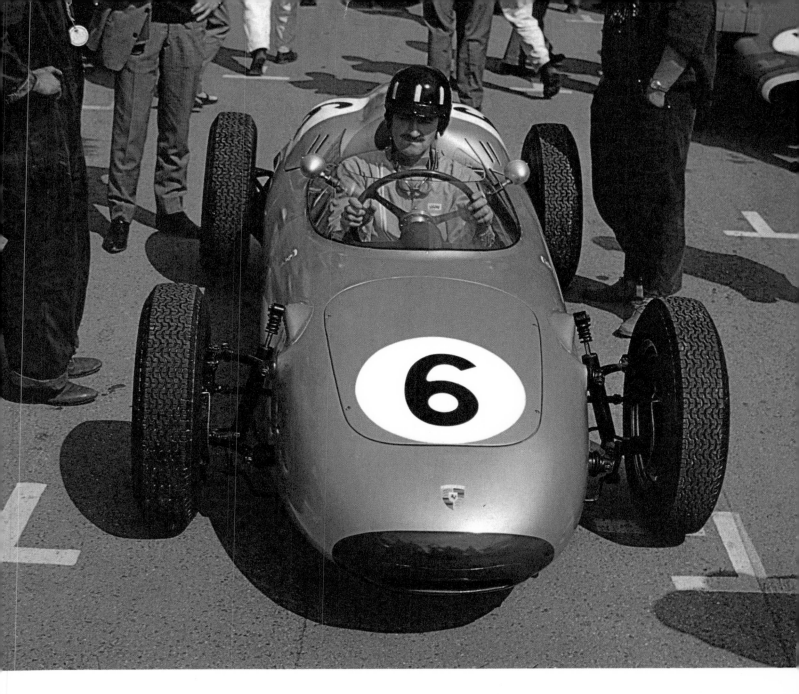

PORSCHE, 1960

America's first bid for honours in Formula I was a case of too late, and too slow. With rear-engined designs firmly in the ascendant, Lance Reventlow's Scarab conformed to the European fashion of yesteryear, and it did not appear on the scene until the last season of the old $2\frac{1}{2}$-litre rules. The twin o.h.c. 2,441 c.c. four-cylinder engine had desmodromic valves and fuel injection, and developed 250 b.h.p. It lived at the front of a conventional chassis with all wheels independently sprung by double wishbones and coils. Only once did it start in a European *grande épreuve,* and then it failed to perform with distinction. Though the Reventlow *equipe* abandoned G.P. racing thereafter Scarabs with American engines have subsequently done well in *formule libre* events at home.

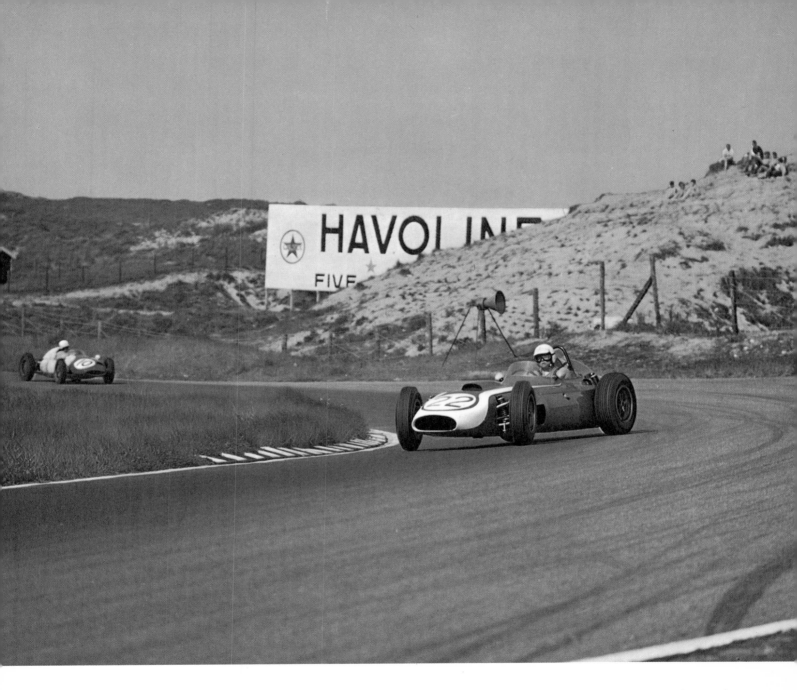

SCARAB, 1960

The shape of things to come? At the time of writing, apparently not yet, though Peter Westbury's exploits in hill-climbing on four-wheel-drive Ferguson and Felday cars are an interesting pointer. Purely a test-bed, the Ferguson looked old-fashioned in 1961 with its driver sitting behind the engine, and only three feet from the tail. But mechanically it was a real breakaway; using a limited-slip differential between front and rear wheels, it offers not only better traction, but greater resistance to wheelspin under acceleration, as well as a reduced tendency for the wheels to lock under braking. Sideways grip is improved, and a Dunlop Maxaret anti-skid braking system is built in—though the car was not raced with this.

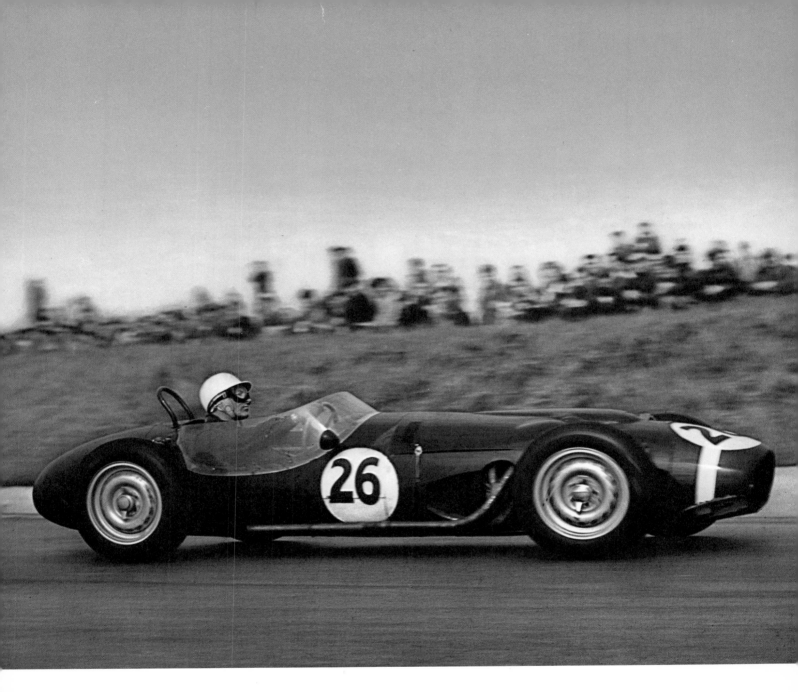

FERGUSON, 1961

This ingenious sports-racing machine acquired the nickname 'birdcage' from its intricate space-frame built up of small-diameter tubes, and weighing only 80 lb. In standard 1960-61 form it was offered with a twin overhead camshaft four-cylinder engine of 2.9-litres' capacity, inclined in the chassis and mounted at the front. Output was 260 b.h.p., and in this guise the 'Birdcage' won both the 1960 and 1961 Nürburgring 1,000-kilometre races. Stirling Moss also won the 2-litre class of the 1959 Rome sports-car G.P. on a car similar to the one here seen competing in the 1961 Targa Florio. A rear-engined version, Tipo 63, also appeared in that year.

MASERATI TIPO 61, 1961

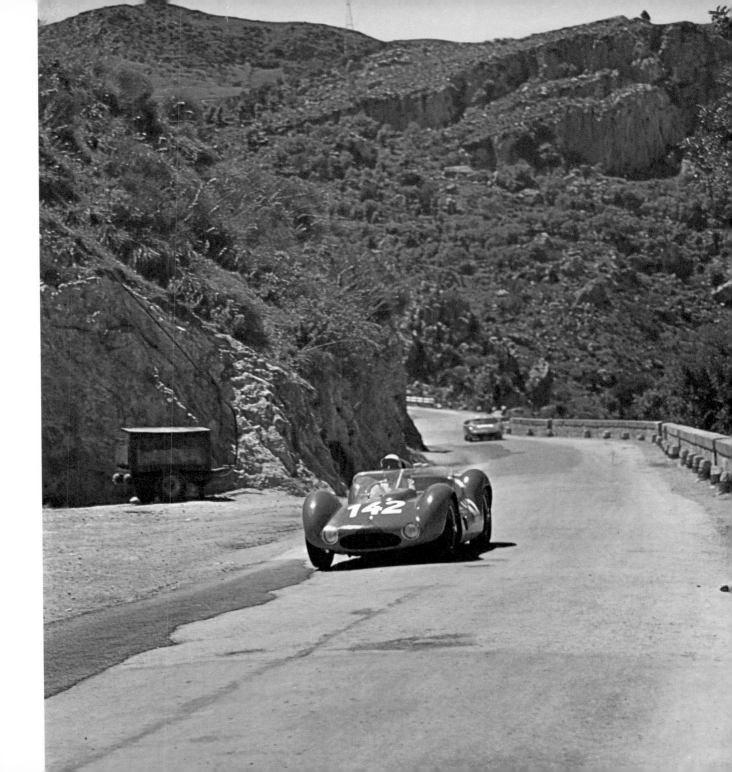

In many ways the spiritual successor of the Amilcar, the M.G. educated a whole generation of Americans in the art of driving for fun, thereby earning many precious dollars for Britain. When the M.G.-A appeared at the 1955 London Show, there were lamentations all round, for the traditional shape of the 'T' family had been jettisoned, and the engine was now a tuned version of the 1,489 c.c. unit found in more pedestrian B.M.C. cars. What is more, the factory no longer called it a 'Midget'. But if the 'A' had lost none of the firmness of suspension or noise of its predecessors, it held the road much better. Over 100,000 were made, and the later cars with the 1,600 c.c. engine would exceed 100 m.p.h.

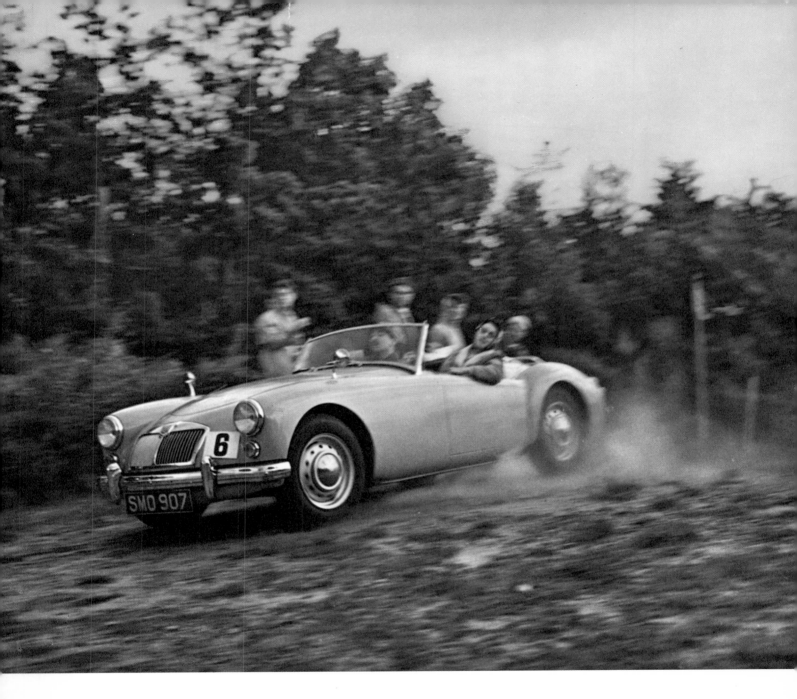

M.G. A-1600, 1961